Dan Flavin
The Architecture of Light

Deutsche Guggenheim BERLIN

Published on the occasion of the exhibition

Dan Flavin: The Architecture of Light

Organized by J. Fiona Ragheb
Deutsche Guggenheim Berlin, November 6, 1999–February 13, 2000

Dan Flavin: The Architecture of Light
© 1999 The Solomon R. Guggenheim Foundation, New York.
All rights reserved.

All works by Dan Flavin
© 1999 Estate of Dan Flavin/Artists Rights Society (ARS), New York

ISBN 0-89207-223-7 (softcover)
ISBN 0-8109-6926-2 (hardcover)

Guggenheim Museum Publications
1071 Fifth Avenue
New York, New York 10128

Deutsche Guggenheim Berlin
Unter den Linden 13–15
10117 Berlin

Hardcover edition distributed by
Harry N. Abrams
100 Fifth Avenue
New York, New York 10011

Printed in Germany by Cantz

Design: Bruce Mau Design
Bruce Mau with Chris Pommer

Cover: Dan Flavin, *untitled*, 1963–66 (detail)

Photography: David Heald, Ellen Labenski, Sally Ritts

Contents

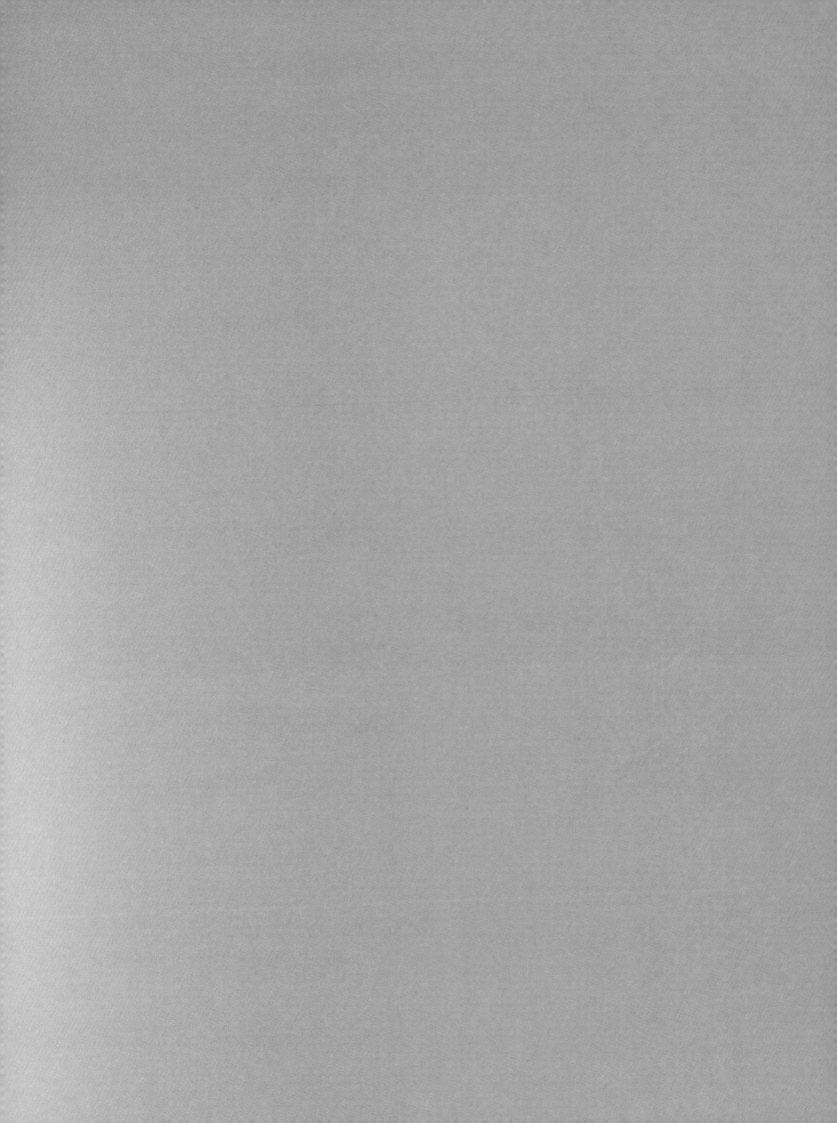

Foreword
Dr. Rolf-E. Breuer

"'Monuments' for Tatlin" is the title of a series of works created by Dan Flavin between 1964 and 1982. This homage to the Russian Constructivist artist Vladimir Tatlin shows the importance of the Russian avant-garde for the arts from postwar to contemporary works. Many of the ideas developed by the artists in the artistically and intellectually inspiring atmosphere in Russia at the beginning of this century were taken up and readapted by their colleagues in Western Europe and the United States decades later. After the exhibition *Amazons of the Avant-Garde*, we are now pleased to present Dan Flavin, an artist who was in the 1960s as revolutionary as Russian women artists had been in their time. He used industrial fluorescent light as an aesthetic medium to free "pictures" from their conventional frame and to create immaterial light compositions. Flavin's radically new art form offers a fascinating view of the interplay of light and architecture.

The exhibition *Dan Flavin: The Architecture of Light*, which covers close to twenty-five years, shows key works from the Solomon R. Guggenheim Foundation collection. The eight installations—Flavin's earliest compositions to his major works of the '80s—will cast an entirely new light, this time literally, on our exposition hall on Unter den Linden.

After James Rosenquist and Helen Frankenthaler, two artists who were the subjects of previous exhibitions here, Flavin fills another gap in American postwar art in the Deutsche Guggenheim Berlin program. All three belong to the same generation, but followed completely different avenues. Frankenthaler created her own lyrical variant of Abstract Expressionism, while Rosenquist advanced Pop art with his monumental paintings. Flavin, on the other hand, departs from brush and color: his color is light.

Preface
Thomas Krens

The Guggenheim Museum's acquisition philosophy is distinguished by its three-fold approach to collecting the art of our time. While endeavoring to present an encyclopedic model of artistic production with masterpieces that exemplify the zenith of aesthetic achievement, the collection has also been shaped by a deep commitment to the work of individual artists in depth, as well as to site-specific commissions that engage the unique spaces of the Frank Lloyd Wright–designed rotunda. These latter two approaches provide a sharp focus within the broader context of an extensive twentieth-century collection, and are embodied by the work of Dan Flavin within the Guggenheim's holdings.

Our relationship with the late artist and his work has been enduring and rewarding, preceding even the 1959 opening of the Wright building. In those early years, Flavin was employed as a clerk during the museum's construction, providing him with ample opportunity to observe at close hand the work of an architect he revered. Further opportunity came in 1971, when Flavin was commissioned to create a piece for the *Sixth Guggenheim International*. Using Wright's rotunda as his canvas, he melded fluorescent luminescence with architectural bravura in *untitled (to Ward Jackson, an old friend and colleague who, during the Fall of 1957 when I finally returned to New York from Washington and joined him to work together in this museum, kindly communicated)*, which occupied one full turn of the spiral ramps and subsequently entered the museum's collection. Flavin's installation marked the institution's foray into commissioning site-specific works, a practice that has evolved over the years to include works by such noted artists as Jenny Holzer, Mario Merz, and Claes Oldenburg and Coosje van Bruggen. In the early 1990s, our commitment to Flavin's work was further strengthened by two significant events in the institution's history. The first was the museum's acquisition of an impressive collection of Minimal and Conceptual art assembled by Count Giuseppe Panza di Biumo, which included many striking examples of Flavin's work. If it were not for Dr. Panza's prescient vision, this exhibition would not be possible. The second was the 1992 reopening of the museum after an extensive renovation and expansion project. On that occasion, Flavin's original 1971 conception was realized in its entirety for the first time, bathing the entire rotunda in a glorious wash of light and color. A more perfect marriage of art and architecture, each playing to the strengths of the other, could not be imagined.

Our partnership with Deutsche Bank has been equally gratifying, albeit not as lengthy. It is thus with great pleasure that, for the first time in the Deutsche Guggenheim Berlin's program, we present an exhibition drawn entirely from the Guggenheim's extensive collection. We are delighted to collaborate with a partner whose enlightened support of the visual arts is an exemplary model of corporate support, and we take this occasion to share our collection in recognition of our unique alliance. For his commitment to, and enthusiastic support of, this mutually rewarding endeavor, my heartfelt appreciation goes to Dr. Rolf-E. Breuer, Spokesman of the Board of Managing Directors of Deutsche Bank.

Acknowledgments
J. Fiona Ragheb

It is a pleasure to present the work of Dan Flavin at the Deutsche Guggenheim Berlin, for Flavin's work has always been at home in Germany, and in fact he created a site-specific installation for the Hamburger Bahnhof in Berlin. While drawn from the Guggenheim's in-depth holdings of the artist's work, this exhibition nonetheless required the international collaboration of many talented individuals to ensure its success.

The Guggenheim Museum is dedicated to the presentation and inter-pretation of its collection, and I am grateful for Thomas Krens's contin-ued commitment to the art of the '60s and '70s, and for Lisa Dennison's expert knowledge of the permanent collection. *Dan Flavin: The Architecture of Light* has also benefited from the wise counsel of Heiner Friedrich and Michael Govan, as well as Stephen Flavin and Tiffany Bell, who provided insights and graciously entertained inquiries as they arose. Steve Morse kindly made himself available to clarify the technical issues that arose in planning the installation. My appreciation must be extended as well to Nancy Spector, who proved to be an invalu-able sounding board during all stages of the project's planning and development.

For their contributions to this catalogue, I am privileged to acknow-ledge Tiffany Bell, Project Director of the Dan Flavin catalogue raisonné; Francis Colpitt, Associate Professor in the Division of Visual Arts at the University of Texas at San Antonio; Jonathan Crary, Associate Professor of Art History at Columbia University; Michael Govan, Director, Dia Center for the Arts; the artist Joseph Kosuth; Michael Newman, Principal Lecturer in Research at Central Saint Martins College of Art and Design, The London Institute; and Brydon E. Smith, former Curator of Twentieth Century Art at the National Gallery of Canada, Ottawa, whose varied perspectives have enriched the discussion of Flavin's work. The creative talents of Bruce Mau Design, in particular Chris Pommer, Chris Rowat, and Amanda Sebris, have resulted in a catalogue design that elegantly captures the brilliance of Flavin's work.

Many individuals from the Chinati Foundation, Fondazione Prada, Margo Leavin Gallery, Rhode Island School of Design, and David Zwirner Gallery kindly supplied information and research materials that enhanced our archives.

It was a pleasure to collaborate with my colleagues at Deutsche Bank, whose sensitivity to Flavin's work and whose generous cooperation facilitated the development of this project. In particular, the willing col-laboration of Dr. Ariane Grigoteit and Friedhelm Hütte, curators of the Deutsche Bank Collection, has made this exhibition possible. The

enthusiasm and dedication of Svenja Simon, Deutsche Guggenheim Berlin Gallery Manager, assisted by Sara Bernshausen and Kathrin Conrad, Deutsche Bank Arts Group, to this project has been unyielding, while Uwe Rommel and his team of exhibition assistants deftly managed the installation. Britta Färber, Deutsche Bank Arts Group, provided input at key moments and was a gracious liaison. The creative efforts of Markus Weisbeck of Surface Gessellschaft für Gestaltung, are responsible for the design of the exhibition materials.

At the Solomon R. Guggenheim Museum, I am indebted to Kara Vander Weg, Project Curatorial Assistant, who skillfully coordinated the many aspects of this project with outstanding dedication. Bridget Alsdorf, Collections Curatorial Assistant, lent her thorough eye to the many details involved. Curatorial interns Michelle Anderson, Kalliopi Minioudaki, and Gudrun Meyer also generously gave of their time. The complexities involved in planning the installation were capably handled by Sean Mooney, Exhibition Design Manager; Ana Luisa Leite, Exhibition Design Assistant; Marcia Fardella, Senior Graphic Designer; Natasha Sigmund, Senior Registrar for Collections; Scott Wixon, Manager of Art Services and Preparations; and Paul Bridge and Derek DeLuco, Art Handlers. At crucial junctures in the development of this project, Betsy Ennis, Senior Publicist; Ben Hartley, Director of Corporate Communication and Sponsorship; Nic Iljine, European Representative; Anne Leith, former Planning and Operations Manager; Maria Pallante, Assistant General Counsel; and Paul Pincus, Director of International Planning and Operations, provided assistance with the innumerable details.

The talented staff of the Guggenheim's Publications department under the leadership of Anthony Calnek, Director of Publications, skillfully managed the production of this catalogue. I am particularly indebted to Elizabeth Franzen, Manager of Editorial Services; Elizabeth Levy, Managing Editor/Manager of Foreign Editions; and Esther Yun, Assistant Production Manager; as well as to Meghan Dailey, Assistant Editor, and Rachel Shuman, Editorial and Administrative Assistant. Maureen Clarke and David Frankel also lent their editorial skills, while Bernhard Geyer, Jürgen Riehle, and Marga Taylor sensitively translated and edited the texts in German. David Heald, Chief Photographer and Director of Photographic Services, along with Ellen Labenski, Assistant Photographer, completed the challenging task of photographing Flavin's work, assisted by Kimberly Bush, Manager of Photography and Permissions.

Of Situations and Sites
J. Fiona Ragheb

*What has art been for me? In the past, I have known it
(basically) as a sequence of implicit decisions to combine
traditions of painting and sculpture in architecture with
acts of electric light defining space. . . .*
　　　　　　—Dan Flavin, "'. . . in daylight or cool white.'
　　　　　　an autobiographical sketch," 1965

Dan Flavin's pioneering use of light began in the early 1960s, when he
affixed both incandescent and fluorescent bulbs to the margins of
Masonite constructions. Flavin hung these square objects on the wall to
create what he would call "icons." While he would soon jettison the
structural elements in favor of fluorescent fixtures alone, these early
icons nonetheless embodied the two poles that would come to define his
work over the course of his career. The frontal, hieratic orientation of the
icons would continue in those works that remained oriented to the wall
in a two-dimensional plane; the use of the perimeter—Flavin applied
light fixtures to the sides and edges of the constructions—anticipated
the articulation of space in works that engaged three-dimensionally with
their surroundings. The solicitation of the architectural frame that char-
acterizes these latter works links them to a practice of site-specificity
that came to the fore among artists of Flavin's generation. Yet while on
the face of it, the specificity of Flavin's work derives from its ties to a
physical location, it surpasses these material confines to engage as well
with overlapping notions of site as a conceptual and phenomenological
construct.[1]

　Flavin's embrace of the unadorned fluorescent fixture first appeared in
the diagonal of personal ecstasy (the diagonal of May 25, 1963), which
consisted of a standard, commercially available eight-foot gold light tube
affixed to a wall at a 45-degree angle. His studio awash in the golden
light, Flavin recognized the fluorescent light as the basic integer of his
nascent practice: "There was literally no need to compose this system
definitively; it seemed to sustain itself directly, dynamically, dramatically
in my workroom wall—a buoyant and insistent gaseous image which,
through brilliance, somewhat betrayed its physical presence into approxi-
mate invisibility."[2] This breakthrough would set the tone for an increas-
ingly complex effort that circumvented the limits imposed by frames,
pedestals, and other conventional means of display, while bound by the
limited vocabulary imposed by the standard lengths (two, four, six, and
eight feet) and colors (blue, green, pink, red, yellow, and four varieties of
white) of mass-produced fluorescent fixtures.[3]

In dispensing with the hand-wrought armature and rendering the industrially produced fixture coextensive with its environment, Flavin shared a sensibility with other artists of the period such as Carl Andre, Donald Judd, and Robert Morris, whose use of industrial materials, nonhierarchical relationships among component parts, and elementary forms would become salient characteristics of Minimal art. But what particularly became a lightning rod in the critical debates surrounding the "new sculpture" was the acknowledgment of the contextual frame as integral to the reading of the work.[4] By externalizing traditional notions of composition, Minimalist sculpture took "relationships out of the work and [made] them a function of space, light, and the viewer's field of vision."[5] Perhaps more than any other artist of this generation, Flavin rendered these relationships inextricable from the environment in which his work was presented, demonstrating what the artist Mel Bochner termed "an acute awareness of the phenomenology of rooms."[6]

This acute awareness stemmed in good measure from Flavin's rejection of studio production—long the bastion of the artist-hero—in favor of devising his installations specifically for a given locale. As early as 1964, for an exhibition at the Green Gallery, New York, he carefully planned the configuration of works in consideration of the gallery confines. He would elaborate on this practice throughout his career, applying it broadly both to entire exhibitions, such as the 1973 *corners, barriers, and corridors in fluorescent light from Dan Flavin*, conceived for the galleries of The Saint Louis Art Museum, and to individual works, such as *untitled (to Ward Jackson, an old friend and colleague who, during the Fall of 1957 when I finally returned to New York from Washington and joined him to work together in this museum, kindly communicated)*, which Flavin created for the 1971 *Sixth Guggenheim International*, a survey exhibition of contemporary art.[7] As a result, his works articulate the idiosyncrasies, however great or small, of a given space, whether that space is a drawing cabinet of the Stedelijk van Abbemuseum, Eindhoven—the intersecting spans of *greens crossing greens (to Piet Mondrian who lacked green)*, 1966 (plate 3), created for the exhibition *Kunst Licht Kunst*—or a corner of the Margo Leavin Gallery, Los Angeles—the lean sixteen-foot slice of light called *untitled (fondly, to Margo)*, 1986 (plate 8). Even Flavin's choice of the term "situation" to describe his work suggests its inherent adaptability to the distinctive character of a given site. In this sense, his "situations" engaged with a burgeoning practice of site-specific art that looked to the physical site for its definition.

Closely on the heels of *the diagonal of personal ecstasy (the diagonal of May 25, 1963)*, Flavin began to explore three-dimensional space, reorienting another basic eight-foot light unit so that it projected almost imperceptibly from a corner, in *pink out of a corner (to Jasper Johns)*, 1963–64. He continued to explore this same terrain in a number of untitled works from 1963–66, as well as the related "corner" monuments from 1966, *monument on the survival of Mrs. Reppin* (plate 2) and *monument 4 for those who have been killed in ambush (to P.K. who reminded me about death)*. Flavin would return to the corner again and again throughout his career. It was also in 1966 that he realized *greens crossing greens (to Piet Mondrian who lacked green)* in Eindhoven, the first of his "barrier" pieces, and at the time his most marked venture into three dimensions. Two spans of covered fixtures, two and four feet long respectively, traversed the room and crossed in the middle, directly intervening in the visitor's experience of the gallery space by barring easy access to more than half of it. In Flavin's mise-en-scène, the inter-

play of light and space perceptually and often physically altered the experience of the space, creating works that explored "variations on the theme of confinement and liberation."[8]

The spatial framework in which Minimalist forms were experienced was a paramount consideration as a "structuring factor both in its cubic shape and in terms of the kinds of compression different sized and pro-portioned rooms [could] effect upon the object-subject terms."[9] It is in this sense that "architecture was considered in terms of its existence as a limit."[10] Flavin was not hampered by such limits, however, for he had discovered that he could use light to reshape and redefine space.

> Now the entire interior spatial container and its components—wall, floor and ceiling, could support a strip of light but would not restrict its act of light except to enfold it. . . . While the tube itself has an actual length of eight feet, its shadow, cast by the supporting pan, has but illusively dissolving ends. . . . Realizing this, I knew that the actu-al space of a room could be disrupted and played with by careful, thorough composition of the illuminating equipment. For example, if an eight-foot fluorescent lamp [can] be pressed into a vertical corner, it can completely eliminate that definite juncture by physical struc-ture, glare and doubled shadow. A section of wall can be visually dis-integrated into a separate triangle by placing a diagonal of light from edge to edge on the wall. . . . These conclusions from completed propositions . . . left me at play on the structure that bounded a room but not yet so involved in the volume of space which is so much more extensive than the room's box.[11]

With his barrier and "corridor" pieces in particular, Flavin would directly intervene in space—rendering large areas inaccessible, preventing the passage of visitors through space, and otherwise altering the experience of the contextual and architectural frame. He approached the gallery confines not as a limit but as an opportunity to use the most immaterial of media for the perceptual manipulation of space.

And yet, although Flavin's works in three dimensions were often tailored to specific locales—simultaneously conditioning and being conditioned by their site—with the exception of certain large-scale commissions they were not permanently rooted to the locus of their inception. Freed from their original moorings, these works could readily be shown in any milieu that met the necessary installation conditions. Such "rootlessness" gives credence to Rosalind Krauss's contention that the history of modern sculpture is based upon the fact that there are no more sites.[12] The logic of sculpture is inseparable from what Krauss has called the "logic of the monument," a logic triangulated by commemoration, representation, and symbolization, and one in which the object functions as a marker or chronicle on a symbolic level.[13] Given the changing conventions of sculptural production, however, this logic has ceased to operate in twentieth-century sculpture. Krauss pin-points the turning of this tide in the work of Constantin Brancusi, which is wholly abstract and self-referential in the acknowledgment of its process of construction and its mode of display, thus evincing "an absolute loss of place" and revealing "meaning and function as essen-tially nomadic."[14] It is no coincidence, in this regard, that Brancusi proved an important touchstone for more than one artist of the 1960s.[15] Indeed, shortly after Flavin produced the diagonal of personal ecstasy (the diagonal of May 25, 1963), he rechristened the work the diagonal of May 25, 1963 (to Constantin Brancusi), in recognition

of the sensibilities shared by the uncontainable glow of the fluorescent lamp and Brancusi's *Endless Column*.[16]

Thierry de Duve has suggested that "site"—a concept he theorizes as a harmony of place, space, and scale—can be recuperated only by linking two of these factors at the expense of a third, which at a later moment is paradoxically redefined and reinscribed as if in recognition of its failure.[17] This strategy is borne out by Flavin's work, which, like Brancusi's, ignores place in deference to space and scale; his orchestrations of light in space celebrate merely "barren rooms."[18] Indeed, if the typical museum experience is "a matter of going from void to void" in which "hallways lead the viewer to things once called 'pictures' and 'statues,'"[19] Flavin inverted this experience and highlighted the spatial container. The voids instead became the means by which he reconceptualized sculpture and space, investing corners, baseboards, ceilings, hallways, and stairwells—in short, every place but that traditionally reserved for the display of art itself—with a previously unacknowledged presence.[20]

In the equation of place, space, and scale, the importance of place lies in its symbolic role as the marker of cultural meaning. That such symbolism is absent from Flavin's work is no surprise, given his observation that "art is shedding its vaunted mystery for a common sense of keenly realized decoration. Symbolizing is dwindling—becoming slight."[21] Yet despite Flavin's protestations that his art "is what it is, and it ain't nothin' else. . . . Everything is clearly, openly, plainly delivered. There is no hidden psychology, no overwhelming spirituality you are supposed to come into contact with,"[22] symbolic content is nonetheless present here. For Flavin's fluorescent constructions, while usually untitled, are typically accompanied by dedications to his family, friends, colleagues, and others, ranging from the artist Donald Judd, Judd's son Flavin Starbuck Judd, and the Guggenheim's then-archivist Ward Jackson, to professional acquaintances such as his dealer Margo Leavin, collectors Jan and Ron Greenberg, and even dealer Rudolf Zwirner's mother-in-law Mrs. Reppin, to historical figures including Brancusi, Henri Matisse, Mondrian, Vladimir Tatlin, and William of Ockham.[23] Belying the generic quality of the industrial fixtures from which these works are made, Flavin's dedications insist on a sentiment and warmth absent from the prevailing rhetoric of Minimalism. It is here among the proper names of Flavin's dedications that place reemerges, forming an autobiographical constellation of touchstones that describes the artist's personal and professional life in abbreviated form. From this vantage point, the commemorative intonation of Flavin's dedications, together with his solicitation of the architectural frame, resonate as "an attempt to reconstruct the notion of site from the standpoint of having acknowledged its disappearance."[24]

In addressing his work to the space of the museum or gallery, Flavin also addressed it to the larger discursive frame within which the institutional space is understood. By "celebrating barren rooms" he was implicitly calling attention to the emptiness of the museum, and by extension of the conventions that structure art history. His rejection of the labels "sculpture" or "environment" for his work, in favor of the terms "situation" or "proposal," seems to reflect an awareness of the increasing inefficacy of such historically bounded terms. In referring to his "icons" as "dumb—anonymous and inglorious . . . as mute and indistinguished as the run of our architecture" he drained them of the modernist aura invested in the autonomous aesthetic object.[25] Even the choice of light for his artistic medium ironically played upon the con-

ventional role of light within the museum as a means to enhance the neutrality of the surroundings and draw attention to the art object itself.[26] And his fascination with the corner was to some degree an engagement with the conventions of perspective and the notion of painting as a "window on the world," ideas that have informed the development of art since the Renaissance. This reference is most explicit in an *untitled* work from 1966, composed of four fluorescent tubes that delineate a square.[27] Installed across a corner at eye-level, it unmistakably alludes to painting. Yet instead of permitting the converging walls to emulate the perspectival space of painting, Flavin dissolves it through the careful placement of the fluorescent lamps. In this sense, then, the "site" of Flavin's work is also firmly rooted in that of the ideological apparatus and context that his work engages in dialogue.

Perhaps the most important site that Flavin's work engages, however, is that of the viewer's subjectivity. For while the terms "situation" and "proposal" aptly elucidate the sensibility of his installations, and also reference the sometimes fleeting nature of those installations' existence, it is equally telling that they underscore the contingency of reception. The Minimalist artists' acknowledgment of the contextual frame in which the artwork was perceived implicitly interpolated the viewer into that context.[28] This is nowhere more apparent than in Flavin's light constructions, which cast a seductive glow on the spectator's skin. Whether politely illuminating a corner or aggressively invading the viewer's space, the atmospheric light of Flavin's "situations" is mapped onto building and body alike, enveloping both in a palpable wash of color that binds together object and observer to an extent unprecedented in the work of his contemporaries, such that "the insistent rays . . . deprive the spectator of even his sure ground as the *seer* by rendering him, too, as a possible object."[29] This conflation of object and observer was not lost on Flavin, who mused that "by making the space and the on-looker visible, light, in a way, creates them. . . ."[30]

While site-specificity has conventionally connoted an inseparability between a particular physical place and the object that inhabits it, the course of contemporary aesthetic practice has disrupted this relationship. A gradual loosening of the ties that bind artistic production to place has meant that "the 'site' of art evolves away from its coincidence with the literal space of art, and the physical condition of a specific location recedes as the primary element in the conception of a site."[31] Thus, if Flavin's work is site-specific, it is so in the paradoxical sense that it is not. As de Duve remarks, "The site of all *in situ* art is a 'nonsite.'"[32] This "rootlessness" liberates Flavin's work from a unique physical place, permitting it instead to operate on a number of discursive registers and within interrelated sites of specificity—that of the proper name, that of the institutional frame, and that of the viewing subject.

1. See Miwon Kwon, "One Place after Another: Notes on Site-Specificity," *October* 80 (spring 1997), pp. 85–110, for a discussion of the transformation of the conception of the site in art of the last thirty years.
2. Dan Flavin, "'. . . in daylight or cool white.' an autobiographical sketch," reprinted in *Dan Flavin: fluorescent light etc. from Dan Flavin*, exh. cat. (Ottawa: National Gallery of Canada, 1969), p. 18.
3. Flavin would later add the circular fixture and the ultraviolet light to his repertoire. While for the most part he made use of standard lengths, on occasion he employed other, less common, stock fixtures and lengths. Thus, for example, in his 1987 exhibition at Donald Young Gallery in Chicago, he created a series dedicated to Vladimir Mayakovsky composed of light fixtures from the Duralee Staggered Strip series, manufactured by the Duray Fluorescent Manufacturing Co.

4. See most notably Michael Fried's "Art and Objecthood," *Artforum* (New York) 5, no. 10 (summer 1967), pp. 12–23, reprinted in Gregory Battcock, ed., *Minimal Art: A Critical Anthology* (Berkeley: University of California Press, 1995), pp. 116–47; Donald Judd, "Specific Objects," *Arts Yearbook* (New York) 8, (1965); Robert Morris, "Notes on Sculpture, Part I," *Artforum* (New York) 4, no. 6 (February 1966), pp. 42–44; "Notes on Sculpture, Part II," *Artforum* (New York) 5, no. 2 (October 1966), pp. 20–23; and "Notes on Sculpture, Part III," *Artforum* (New York) 5, no. 10 (summer 1967), pp. 24–29.

5. Morris, "Notes on Sculpture, Part II," in Battcock, p. 232.

6. Mel Bochner, "Serial Art Systems: Solipsism," *Arts Magazine* 41, no. 8 (summer 1967), p. 40.

7. That entire exhibitions could be considered "site-specific" is clear from Peter Plagens's review of Flavin's Saint Louis exhibition as "a superbly orchestrated megawork which transcends the individual pieces . . . an ingenious synthesis of individual work(s), environmental work(s), and reciprocity with the architecture." Plagens, "Rays of Hope, Particles of Doubt," *Artforum* (New York) 11, no. 10 (summer 1973), p. 34. The Solomon R. Guggenheim Museum's own rich history of commissioning and collecting site-specific works dates to the 1971 *International* and Flavin's contribution to it, which was "critically fitted to the inconsistent dimensions of the variable architecture. There was no other choice that I could sense. Otherwise, I preferred and designed for the widest (deepest) area partially open in the rear for maximum spread of light in a repeating sequence of interpenetrations and accents." Flavin, letter to Thomas Messer, June 24, 1971, Guggenheim Museum Archives. The work was conceived so that it could be extended to fill the entire rotunda of the Frank Lloyd Wright–designed space, floor to ceiling, as was done on the occasion of the museum's reopening in 1992.

8. Emily S. Rauh, "Introduction," *corners, barriers and corridors in fluorescent light from Dan Flavin*, exh. cat. (Saint Louis: The Saint Louis Art Museum, 1973), p. 4.

9. Morris, "Notes on Sculpture, Part II," in Battcock, p. 233.

10. Germano Celant, "Sculpture, an Inhabitable Architecture," trans. Sharon Krengel, *Rassegna* (Bologna) 36, no. 4 (December 1988). Guest edited by Annalisa Avon and Germano Celant [transl. unpaginated].

11. Flavin, "'. . . in daylight or cool white.' an autobiographical sketch," in *Dan Flavin: fluorescent light etc. from Dan Flavin*, pp. 19–20.

12. Rosalind Krauss, "Echelle/monumentalité, Modernism/postmodernisme: La ruse de Brancusi," in *Qu'est-ce que la sculpture moderne?*, exh.cat. (Paris: Editions du Centre Pompidou, 1986), p. 246. See also Douglas Crimp, *On the Museum's Ruins* (Cambridge, Mass.: The MIT Press, 1993).

13. Krauss, "Sculpture in the Expanded Field," *The Originality of the Avant-Garde and other Modernist Myths* (Cambridge, Mass.: The MIT Press, 1984), p. 279. Flavin seemed to acknowledge this logic in two works from 1966, *monument on the survival of Mrs. Reppin* and *monument 4 for those who have been killed in ambush (to P.K. who reminded me about death)*. In a somewhat atypical fashion, the works are specifically titled "monuments," the designation commemorating events of an ostensibly momentous character. Flavin also made use of this designation in his extended series to Tatlin, which he titled *"monument" for V. Tatlin*, but that was a reference to Tatlin's greatest work, the unrealized *Monument to the Third International*. It was also, in this context, infused with a knowing irony, for Flavin also referred to this series as "pseudo-monuments." He remarked, "I always use 'monuments' in quotes to emphasize the ironic humor of temporary monuments. These 'monuments' only survive as long as the light system is useful (2100 hours)." Flavin, quoted in Suzanne Munchnic, "Flavin Exhibit: His Artistry Comes to Light," *Los Angeles Times*, April 23, 1984.

14. Krauss, "Sculpture in the Expanded Field," pp. 279–80.

15. Carl Andre and Robert Morris are the other artists in the equation. Andre's *Lever* (1966), a row of 137 fire bricks laid side by side, was his attempt, he said, to place "Brancusi's *Endless Column* on the ground instead of in the sky." Quoted in David Bourdon, "The Razed Sites of Carl Andre," *Artforum* (New York) 5, no. 2 (October 1966), p. 15. See also Rolf Lauter *Carl Andre: Extraneous Roots*, exh. cat. (Frankfurt am Main: Museum für Moderne Kunst, 1991), pp. 47–48. Morris took Brancusi as the subject for his 1966 master's thesis at Hunter College, *Form-Classes in the Work of Constantin Brancusi*.

16. Both the dedication and the choice of color were flexible. Flavin's initial choice was admittedly arbitrary in that he indicated that any color could be used, and while he dedicated the work to Brancusi, he subsequently rededicated it to art-historian Robert Rosenblum. See "'. . . daylight or cool white.' an autobiographical sketch," in *Dan Flavin: fluorescent light etc. from Dan Flavin*, pp. 18–19.

17. Thierry de Duve, "Ex situ," *Cahiers du Musée National d'Art Moderne* (Paris), no. 27 (spring 1989), pp. 39–55 (in French); reprinted in *Art and Design Profile*, no. 30: *Installation Art*. Guest edited by Andrew Benjamin. Part of *Art and Design* (London) 8, no. 5/6 (1993), pp. 24–30 (in English). De Duve defines place as "the cultural tie to ground, territory and identity," space as "the cultural consensus on the perceptive grid of reference," and scale as "the human body as measure of all things."

18. *Dan Flavin: fluorescent light etc. from Dan Flavin*, p. 176.

19. Robert Smithson, "Some Void Thoughts on Museums," 1967, in *Robert Smithson: The Collected Writings*, ed. Jack Flam (Berkeley: University of California Press, 1996), p. 41.

20. That Flavin's work has been interpreted as "variations on the theme of confinement and liberation" recalls Krauss's explorations of the category of sculpture, which, she argues, occupied a "categorical no-man's-land" in the 1960s. Instead, sculpture began to func-

tion in terms of a combination of exclusions, which expanded to include that of "architecture" and "not architecture." In this vein Krauss identifies artists such as Robert Irwin, Bruce Nauman, Richard Serra, and Christo, whose work intervenes in the real space of architecture, and explores "a process of mapping the axiomatic features of the architectural experience—the abstract conditions of openness and closure—onto the reality of a given space." "Sculpture in the Expanded Field," pp. 282–87.

21. Dan Flavin, "some remarks . . . excerpts from a spleenish journal." *Artforum* (Los Angeles) 4, no. 5 (December 1966), p. 27.

22. Flavin, quoted in Michael Gibson, "The Strange Case of the Fluorescent Tube," *Art International* 1 (autumn 1987), p. 105. On a basic level, the colors Flavin selected for particular pieces had a certain symbolic value—his 1987 series dedicated to the citizens of the Swiss cantons, for example, uses the colors of the Swiss flag, while a corner piece of 1987 commemorating an anniversary of the Leo Castelli Gallery makes use of all five colors in a fittingly celebratory palette.

23. While this practice takes on increased significance in the context of Flavin's constructions with light, it is not limited to this work. A 1961 watercolor and ink drawing, *to those who suffer in the Congo*, bears a similar dedication and is inscribed with verses from Psalm 21.

24. De Duve, "Ex Situ," in *Art and Design*, p. 25. De Duve goes on to conclude, "So, in that sense, the site of all *in situ* art is a 'non-site,' as Robert Smithson once perceptively remarked."

25. *Dan Flavin: fluorescent light etc. from Dan Flavin*, p. 176.

26. See Dan Graham, "Art in Relation to Architecture, Architecture in Relation to Art," *Artforum* (New York) 17, no. 6 (February 1979), pp. 22–29. As Bochner pointed out early on, the fluorescent tube itself created a perceptual revolution in providing a light that no longer stemmed from a point source but was available in straight lines that obliterate shadow. Bochner, "Serial Art Systems: Solipsism," p. 42. In this regard, the elimination of modeling with light and shade was also a significant departure given the fundamental role of chiaroscuro within the conventions of art history.

27. The work was part of Flavin's solo exhibition at the Nicholas Wilder Gallery, Los Angeles, that year.

28. See Hal Foster, "The Crux of Minimalism," in Howard Singerman, ed., *Individuals: A Selected History of Contemporary Art, 1945–1986*, exh. cat. (Los Angeles: Museum of Contemporary Art and New York: Abbeville Press, 1986), pp. 162–83.

29. Plagens, "Rays of Hope, Particles of Doubt," p. 33.

30. Flavin, quoted in Maïten Bouisset, "L'Espace au néon de Dan Flavin," trans. Lois Grjebine, *Beaux Arts Magazine* 90 (May 1991), p. 133.

31. Kwon, "One Place after Another," p. 91.

32. De Duve, "Ex Situ," in *Art and Design*, p. 25.

the nominal three (to William of Ockham), 1963
Joseph Kosuth

At some point in the early '70s, I began collecting works by other artists I saw as part of my own cultural horizon, those works which had affected me the most and were a serious cause to think. In that group (which included the Donald Judd from Dwan Gallery's *10 x 10* show, and a Frank Stella pinstripe painting, among others) was *the nominal three (to William of Ockham)*, 1963. For me, this work was the quintessential Dan Flavin. By then it was already clear that Flavin (along with Judd) had started the activity of just making art, not sculptures or paintings. It was, simply put, the beginning of the end of Modernism. (There, I said it.) The implications of this were profound, obviously, and they laid the foundations for the major shift in how art that followed would be made.

With *nominal*, Flavin gave us a kind of ready-made. One need not make much of the fact that Marcel Duchamp was an early supporter of his work, beyond saying that Flavin's work was an important early bridge between Duchamp and the art of the '60s. If the battle between Modernism and its other, the alternative contained within, was played out between Pablo Picasso and Duchamp, it has clearly been won by Duchamp in this half of the century. Flavin's work was an early indicator of that victory. Yet, appropriation, be it Andy Warhol's, Flavin's, or my own, took a turn in the '60s toward other meanings than what one identifies as the ready-mades of Duchamp.

The point here is that *nominal* was not a crafted object, it wasn't an optical circus, it didn't seduce or outrage you with its content, it wasn't a display of expression or emotion, and it wasn't even simply a lamp, since it was out of place. It was its own self, as art, because Flavin took the subjective responsibility for it to mean that. *Nominal* really had no external references other than to the issues of artistic practice itself, as he saw them in New York City in 1963. Don't confuse this with art for art's sake; it constituted the beginning of an important critique of the authority of form, which the masterpieces of modernity had begun to represent. It showed art, Flavin's, or it showed nothing. Yet, in order to do this, in order not to be a crafted object or an attempt at formal invention, in order not to satisfy everyone's idea of what an artwork should look like, it needed to utilize the banal: the empty carrier of meaning of an office lamp put out of place. Because *nominal* is Flavin at his (forgive the word) purest, you get the lamp only, not as a part of the act of constructing something larger, which we see in many of his other works. Here the work, as a lamp, offers nothing more: it figuratively flicks on and off, being either banality itself or closer to what Freud called *das Unheimliche*. The questions Flavin's work raised helped all of us that followed.

If, in 1963 (or thereabouts), you could accept *nominal* as an artwork, then you were ready to rethink everything you had been told to think about art. You would have been more than a viewer; you would have been a participant. There was a community and there was a discourse, which this work reflects. The reason *nominal* might be more difficult to accept as art, then or now, is exactly where one locates both Flavin's contribution and his importance. Here we see the young Flavin making a statement, and as he matured, much of his production (with some knockout exceptions) often look more as though he intended to please. Indeed, even such works as those in the Tatlin series, not to mention the many works that followed in dazzling colors, more easily satisfied conventional expectations of what art was supposed to do.

But is it that simple? Modernist convention would have us believe that art is concerned with objects, with color, with space. One of the feints of Flavin is that he gives the viewer all this and usually better, which is more than any painter could hope for. And, even if less so than other work, *nominal*, too, has all of this, the white even being the color of the absence of other colors. Having all of it, appropriating these qualities on the level of a convention to be both utilized and disregarded, they are then made inconsequential; Flavin's giving it to you but employing them for other reasons, making it mean something else. Much of the literature on Flavin's work in recent years (and, who knows, there may even be evidence of it in the present volume) seems to have forgotten the meaning of works such as *nominal*, which is really the basis of why Flavin's contribution matters. That idea of art that Flavin introduced was not for "beauty," nor as a light show; not for the "poetics of illumination," nor for any of those other trite rationalizations so often provided as an excuse for those not really interested in art itself. Much of this, also, is just the literature that intends to celebrate the fame that follows from early recognition, but finally settles down to institutionalizing an artist's production. Sometimes, of course, it is also the artist's fault, as though deep down many of us want to be working-class heroes—all the celebrity yet the public is standing there wondering what it all means—but in that direction there is only the promise of the abyss, which Walt Disney has articulated so very well. Artists can learn that a contribution need not constitute entertainment, much less instant gratification.

PLATE 1
the nominal three (to William of Ockham), 1963
Fluorescent light fixtures with daylight lamps
Edition 2 of 3
6 ft. fixtures; dimensions vary with installation
Solomon R. Guggenheim Museum, New York,
Panza Collection 91.3698

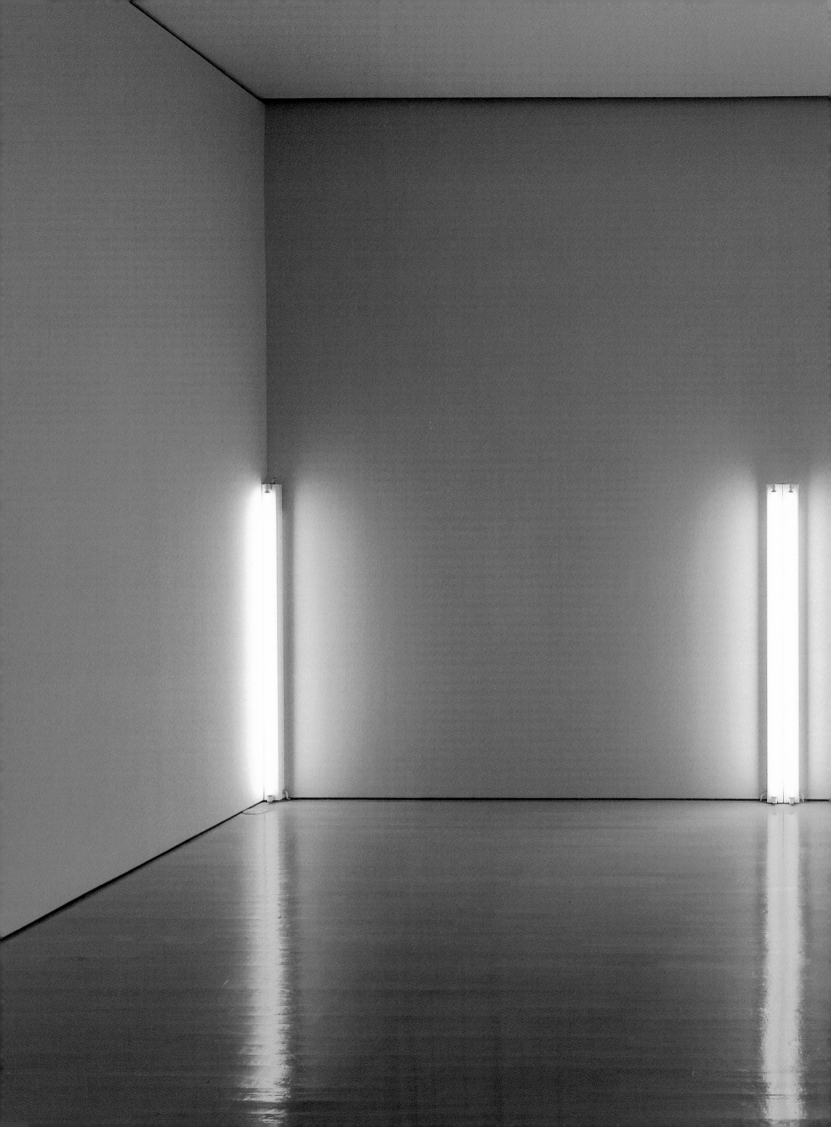

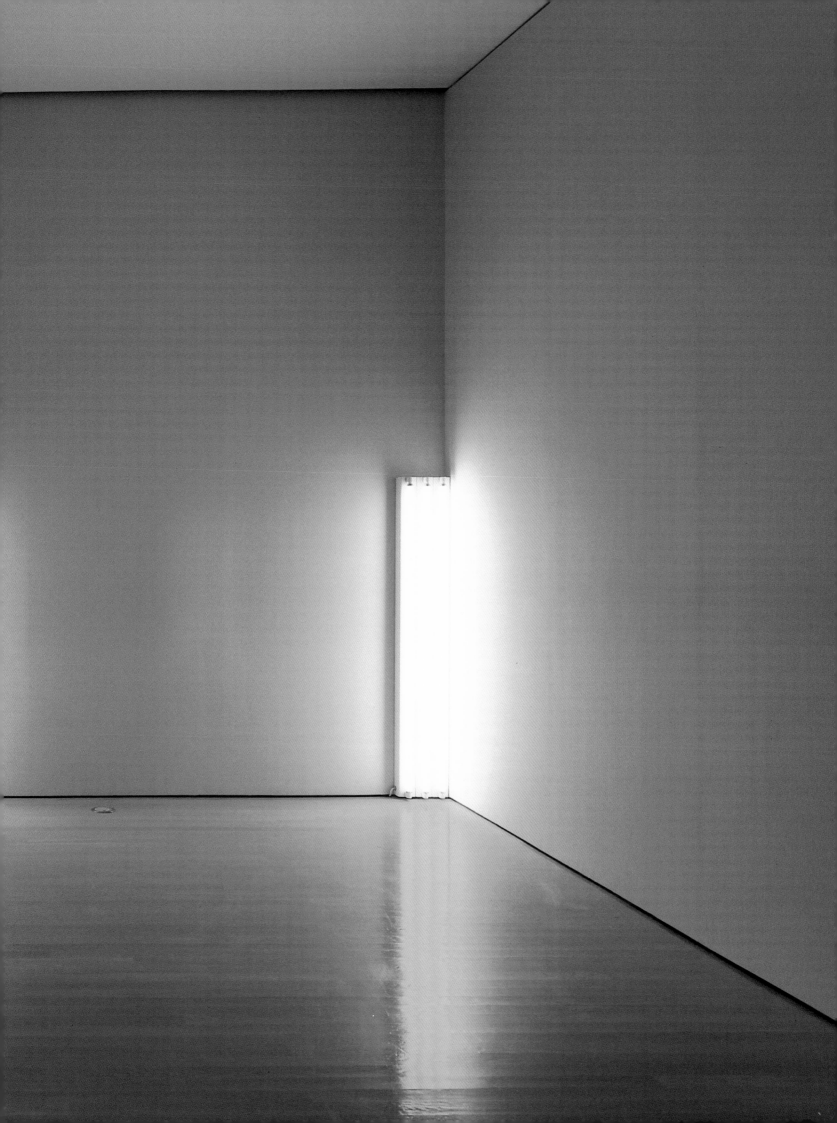

monument on the survival of Mrs. Reppin, 1966
Frances Colpitt

Monument on the survival of Mrs. Reppin, 1966, is one of Dan Flavin's
most unusual and rarely exhibited works of the 1960s. First shown in
1966 at Galerie Rudolf Zwirner, Cologne, the piece occupies a corner
space that is articulated by two white fluorescent tubes, hung horizon-
tally and meeting at the corner. A third white fluorescent spans the
others to form the recessed hypotenuse of a triangle and an emphatic
diagonal in space. A shorter fixture with a red tube placed vertically on
the hypotenuse faces inward and the metal pan on the back of the light
is visible. *Monument on the survival of Mrs. Reppin* consists of just two
colors, but they were specifically chosen from the nine (including four
different whites) that were commercially available.[1] The piece displays
the structural integrity and coloristic succinctness of Flavin's best work.
 Although the horizontality of *monument on the survival of Mrs. Reppin*
differentiates it from the strong vertical emphasis of many of Flavin's
corner pieces, its symmetrical structure and use of the diagonal are
nonetheless representative of the artist's concerns at the time. Flavin
employed the diagonal as a compositional device from the beginning of
his use of electric light. The motif is visible in several of his early
"icons," including *icon V (Ireland dying) (to Louis Sullivan)*, 1962–63,
consisting of a green Masonite box with a truncated, lower-right corner
from which a red incandescent bulb projects, and *the diagonal of May
25, 1963 (to Constantin Brancusi)*, 1963, his first fluorescent work in
which the fixture is installed directly on the wall. Flavin and Donald
Judd, his friend and critical supporter, used the diagonal in order to
avoid "compositional arrangement,"[2] which differentiated their work
from earlier geometric art, such as that of Piet Mondrian or Stuart Davis.
 Most of Flavin's works are dedicated to friends and individuals whose
assistance or influence he appreciated, but the designation "monument"
appears to have been reserved for special acknowledgments. The title
monument on the survival of Mrs. Reppin refers to Rudolf Zwirner's
mother-in-law, although the reference to her survival remains a mystery.[3]
The appellation of "monument" is less oblique in Flavin's homages to
Vladimir Tatlin, begun in 1964: The vertical fluorescents in these works
are typically placed in ziggurat-like configurations reminiscent of the spi-
raling form of Tatlin's *Monument to the Third International*, 1919–20.
Flavin's corner pieces also refer directly to Tatlin's relief constructions of
1915–16, which were similarly suspended between two walls, and also
characterized by strong diagonals, which give them a sense of lift and
urgency comparable to Flavin's most dynamic works. Flavin's use of the
corner began with *pink out of a corner (to Jasper Johns)*, 1963–64, an
eight-foot vertical that was included in his first all-fluorescent exhibition at
the Green Gallery, New York. A similar format, first employed in 1966, in-
volved the delineation of a square with two horizontals and two (or more)
verticals spanning a corner that is softened and rounded by the projected
light. Reviewing these early corner pieces, Fidel A. Danieli noted that "only
Robert Morris's 1964 untitled pyramid [a plywood wedge situated in a cor-
ner] and a series of relief constructions by Vladimir Tatlin come to mind
immediately as influential works operating in these zones."[4]
 Tatlin's Constructivist motto "Real materials in real space" was rele-
vant to the Minimalist project in general. Rather than lighting a room,
Flavin's works were based on "the physical fact of the tube as an object
in place," and he referred to them as "image-object[s]" and only later as
"installations."[5] He was equally adamant that he was not producing

"environments," despite the ambient light that pervades any space occupied by his work. Based on its association with entertainment, characteristic of Happenings and installations by artists such as Allan Kaprow and Claes Oldenburg, the notion of environmental art was rejected by a majority of Minimal artists.[6] Flavin also refused to participate in thematic group exhibitions of kinetic or light art: "I do not want the anticipated carnival atmosphere typical of the 'sound, light, motion' critical-curatorial promotions." He conceived of his work instead as direct, difficult, and even disturbing.[7]

Other 1966 works include a freestanding vertical fixture facing away from the viewer to illuminate the corner. As Jack Burnham observed, "In contrast to the direct intensity of adjacent fluorescent tubes, fixtures turned away from the spectator produce not blackness, but patches of nonlight."[8] This entailed a move away from standard exhibition practices, thrusting the work into the space of the gallery. In 1965, Flavin declared that he wanted to become "involved in the volume of space which is more extensive than the room's box."[9] While monument on the survival of Mrs. Reppin remains dependent upon the wall, such works as greens crossing greens (to Piet Mondrian who lacked green), 1966, utilize the entire exhibition space, creating what Judd called "an interior exoskeleton."[10]

As much as Flavin's work investigates space and light, critics and curators have begun to acknowledge that it is equally about color. Although the artist originally implied that his choice of colors was arbitrary ("a common eight-foot strip . . . light of any commercially available color. At first I chose 'gold'"), Judd declared that "since the tubes are sources of light, their colors seem given and unchangeable."[11] Similar in structure to monument on the survival of Mrs. Reppin but different in temper is monument for those who have been killed in ambush (to P.K. who reminded me about death), a work produced for the Primary Structures exhibition at the Jewish Museum, New York, that same year, which consists of four red fluorescents including a longer horizontal that juts out from the corner and into the gallery space. Based on its fiery color and emphatic horizontality, Richard Kalina sensed "blood and mystery" in this work.[12] The smaller, subtle red fluorescent and the all-suffusing white light give monument on the survival of Mrs. Reppin neither the drama of monument to PK nor the industrial chill of "monuments" for V. Tatlin. With its ascending vertical and predominantly white light, the work has a transcendental, even majestic, effect.

1. Marianne Stockebrand, Dan Flavin/Donald Judd: Aspects of Color (Houston: The Menil Collection, 1998), n.p.
2. Bruce Glaser, ed., "Questions to Stella and Judd," in Gregory Battcock, ed., Minimal Art: A Critical Anthology (Berkeley: University of California Press, 1985), pp. 154–55.
3. Based on a conversation between Kara Vander Weg and David Zwirner, August 10, 1999.
4. Fidel A. Danieli, "Los Angeles," Artforum (New York) 5, no. 6 (February 1967), p. 62.
5. Dan Flavin, "some remarks . . . excerpts from a spleenish journal," Artforum (Los Angeles) 5, no. 4 (December 1966), p. 28; Dan Flavin, "some other comments . . . more pages from a spleenish journal," Artforum (New York) 6, no. 4 (December 1967), p. 23.
6. Frances Colpitt, Minimal Art: The Critical Perspective (Seattle: University of Washington Press, 1993), p. 83.
7. Flavin, "some other comments," p. 23.
8. Jack Burnham, "A Dan Flavin Retrospective in Ottawa," Artforum (New York) 8, no. 4 (December 1969), p. 53.
9. Dan Flavin, ". . . in daylight or cool white," in fluorescent light, etc. from Dan Flavin, by Brydon E. Smith (Ottawa: National Gallery of Canada, 1969), p. 20. This is a revised version of ". . . in daylight or cool white," Artforum (Los Angeles) 4, no. 4 (December 1965), pp. 21–24.
10. Donald Judd, Complete Writings: 1959–1975 (Halifax: Nova Scotia College of Art and Design, 1975) p. 200.
11. Flavin, ". . . in daylight or cool white," p. 18. The reference is to the diagonal of May 25, 1963 (to Constantin Brancusi). Judd, Complete Writings, p. 200.
12. Richard Kalina, "In Another Light," Art in America (New York) 84, no. 6 (June 1996), p. 70

PLATE 2
monument on the survival of Mrs. Reppin, 1966
Fluorescent light fixtures with warm white and red lamps
Edition 1 of 3
2 and 8 ft. fixtures; 71.1 x 361.3 x 255.3 cm
(28 x 142½ x 71 inches)
Solomon R. Guggenheim Museum, New York,
Panza Collection 91.3701

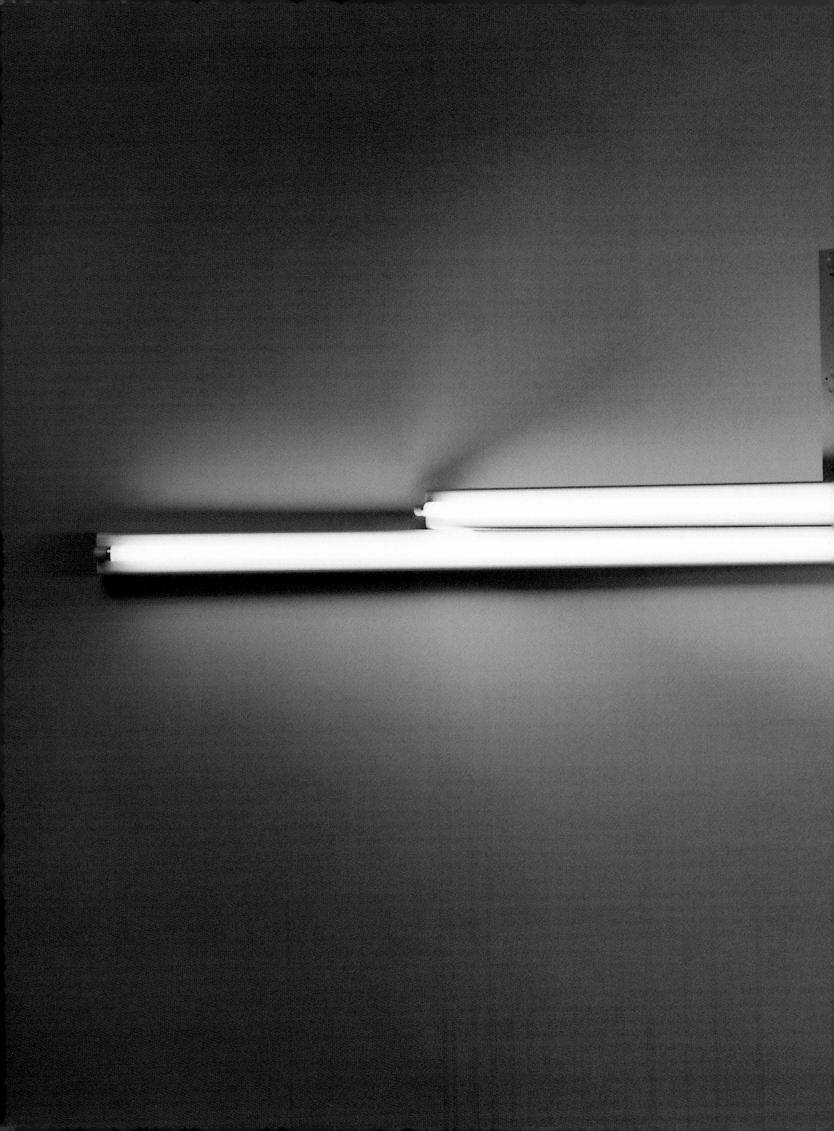

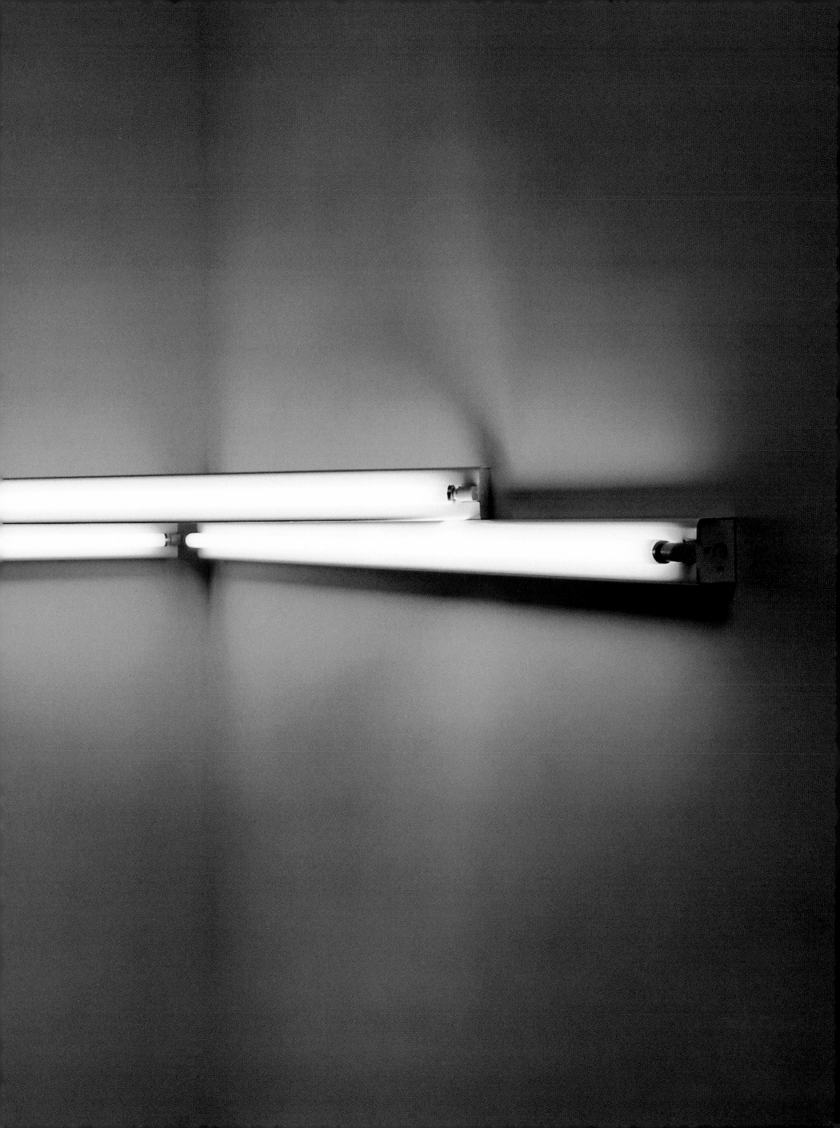

greens crossing greens (to Piet Mondrian who lacked green), 1966

Michael Govan

Dan Flavin's 1966 *greens crossing greens*, made just a few years after his first experiments with fluorescent light, is a culmination of the artist's own definition of his artistic project: "a sequence of implicit decisions to combine the traditions of painting and sculpture in architecture, with acts of electric light defining space."[1]

The work was the first of several that Flavin called "barriers"—linear arrangements of freestanding fluorescent fixtures that literally block physical access across them. As described by the artist, the work "contains two simple, segmented barrier channels of green fluorescent light that cut each other's course arbitrarily each at a different horizontal height over the floor. The length of each channel is variable, restricted by the bounds of the walls."[2] Flavin once remarked in anger that the only historical photograph of the original *greens crossing greens* installation included a viewer standing behind the barrier—which, of course, entirely contradicted the artist's intention.[3]

The two dynamic, crossing diagonals, two-feet and four-feet high, echo the artist's preoccupation with diagonals and corners. Flavin's first electric-light work was an eight-foot-long fixture placed diagonally on the wall. One of his next innovations was a fixture pressed vertically into the corner of a wall to dissolve that edge. Then he placed fixtures across a room's corner (which prefigured the barrier). As a compositional device, the diagonal bears Flavin's debt to Russian avant-garde masters such as Kazimir Malevich, El Lissitsky, and Vladimir Tatlin. He wrote that his early work was "founded in the young tradition of a plastic revolution which gripped Russian art only forty years ago. My joy is to try to build from the 'incomplete' experience as I see fit."[4] While originally conceived for an installation at the Kornblee Gallery in New York, it was certainly not coincidence that when Flavin was invited to participate in the *Kunst Licht Kunst* exhibition at the Stedelijk van Abbemuseum in Eindhoven, he chose to realize his work in the "El Lissitsky drawing cabinet."

One of the most unique aspects of Flavin's light works is the manner in which they encompass their environment and their viewer with the soft luminous glow they reflect over the walls around them. The invention of the barrier is a literal extension of that idea whereby the light's environmental presence is made manifest by its occupation of the gallery's central space. Invading and dividing the territory of the viewer, the work asserts itself in fact as well as effect. If a work of art arrests the viewer's visual attention, the barrier does so physically as well.

Flavin emphasizes the sculptural or architectural aspect of the *greens crossing greens* barrier through the use of fixtures encased in squared Plexiglas in a rhythm of post-and-lintel construction—a rare departure from his usual simple, raw fluorescent tubes. The fixtures' molded-translucent covers further soften and disperse the space-filling quality of green fluorescent light—which is already the most luminous and powerful of the artist's limited palette of commercially available colors (blue, green, pink, red, yellow, and four whites). "Green is used," wrote Flavin, "because it is a pleasant color at this extent brilliant as fluorescent light and soft in the total barrier."[5]

Green also inspired Flavin's dedication of the work *to Piet Mondrian who lacked green*. Flavin used titles only rarely, but often he dedicated artworks. The largest of his 1962 icons is poignantly designed and

dedicated to the memory of his twin brother. He began making nods to his Modernist forebears with his first work in electric light, dedicated to Constantin Brancusi. The litany of dedications also includes Modern architects (Louis Sullivan), writers (James Joyce), musicians (Blind Lemon Jefferson), and numerous living friends and acquaintances.

Flavin's most extensive and sustained series of work (1964–85) is dedicated as *"monuments" to V. Tatlin*. The series, he said, "memorial-izes Vladimir Tatlin, the great revolutionary, who dreamed of art as sci-ence. It stands, a vibrantly aspiring order, in lieu of his last glider, which never left the ground."[6] Flavin's dedications mask reverence with irony and tragic humor. He noted, "I always use 'monuments' in quotes to emphasize the ironic humor of temporary monuments. These 'monu-ments' only survive as long as the light system is useful (2,100 hours)."[7]

Mondrian was another of Flavin's favorites. Flavin collected a few of Mondrian's small drawings, and jokingly organized a mock committee to re-bury the master of abstract painting from his anonymous pauper's grave in New Jersey to a place of honor for which Flavin himself might design the memorial. Dedicated to Mondrian in part because Flavin first installed the work in the Dutchman's home country, the dedication also belies an irony that aspirations and truths can be limited by their context. For Mondrian's work relied on an essential reductive visual vocabulary that combined black and white grid forms with the "primary" colors red, blue, and yellow in pursuit of a universal language. Yet red, blue, and yellow are only "primary" when mixing paint. When mixing light and reflected light, as Flavin does, the "primary" palette reduces to red, blue, and green. It is tempting to read Flavin's note as a modest comment on his own contribution to the tradition of Modernism by his addition of the missing green—that is, the essential possibilities of light.

1. See Dan Flavin, in *Dan Flavin: three installations in fluorescent light* (Cologne: Wallraf-Richartz-Museum and the Kunsthalle Köln, 1973), p. 87.
2. *Dan Flavin: Pink and Gold*, exh. cat., The Museum of Contemporary Art, Chicago, 1967.
3. Conversation with the artist, 1991.
4. Statement in "The Artists Say," *Art Voices* (New York) 4, no. 3 (summer 1965), p. 72. catalogue.
5. Ibid.
6. Ibid.
7. Quoted in Suzanne Munchnic, "Flavin Exhibit: His Artistry Comes to Light," *Los Angeles Times*, April 23, 1984.

PLATE 3
greens crossing greens (to Piet Mondrian who lacked green), 1966
Fluorescent light fixtures with green lamps
2 and 4 ft. fixtures; 133.4 x 584.8 x 303.6 cm
(52¹/₂ x 230¹/₄ x 120 inches) approximate overall
Solomon R. Guggenheim Museum, New York,
Panza Collection 91.3705

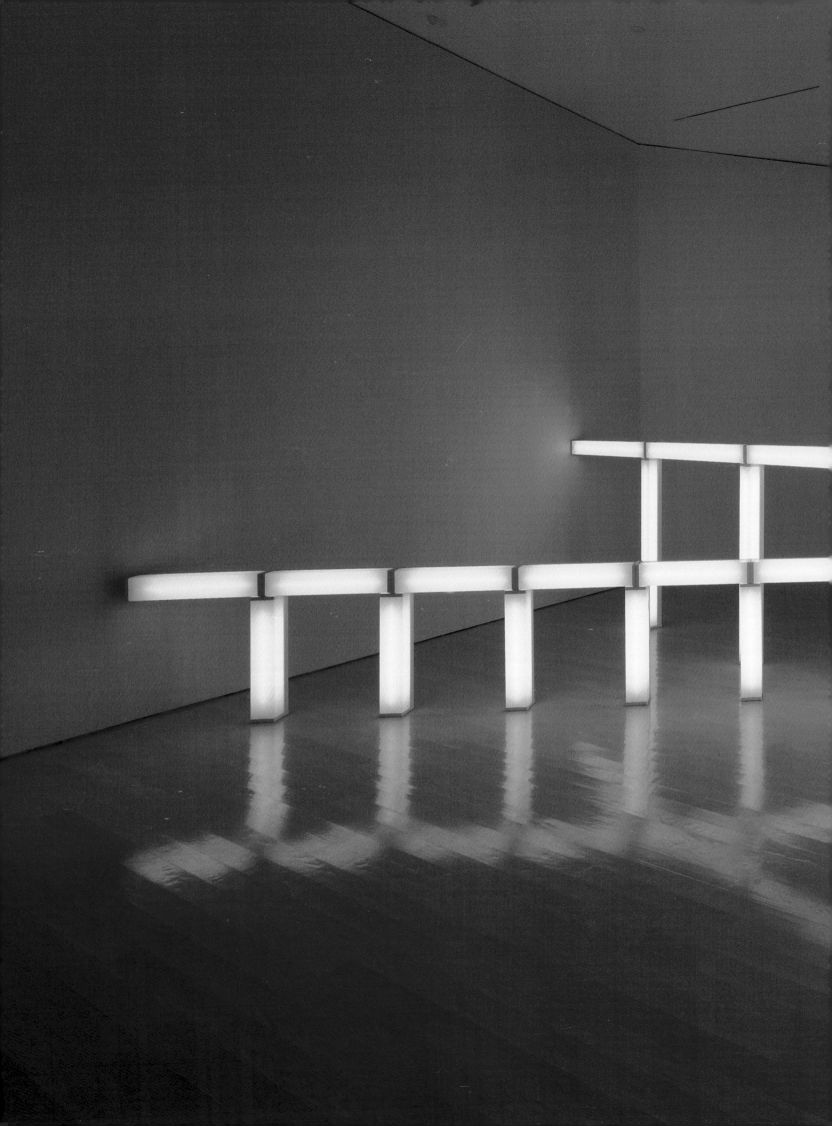

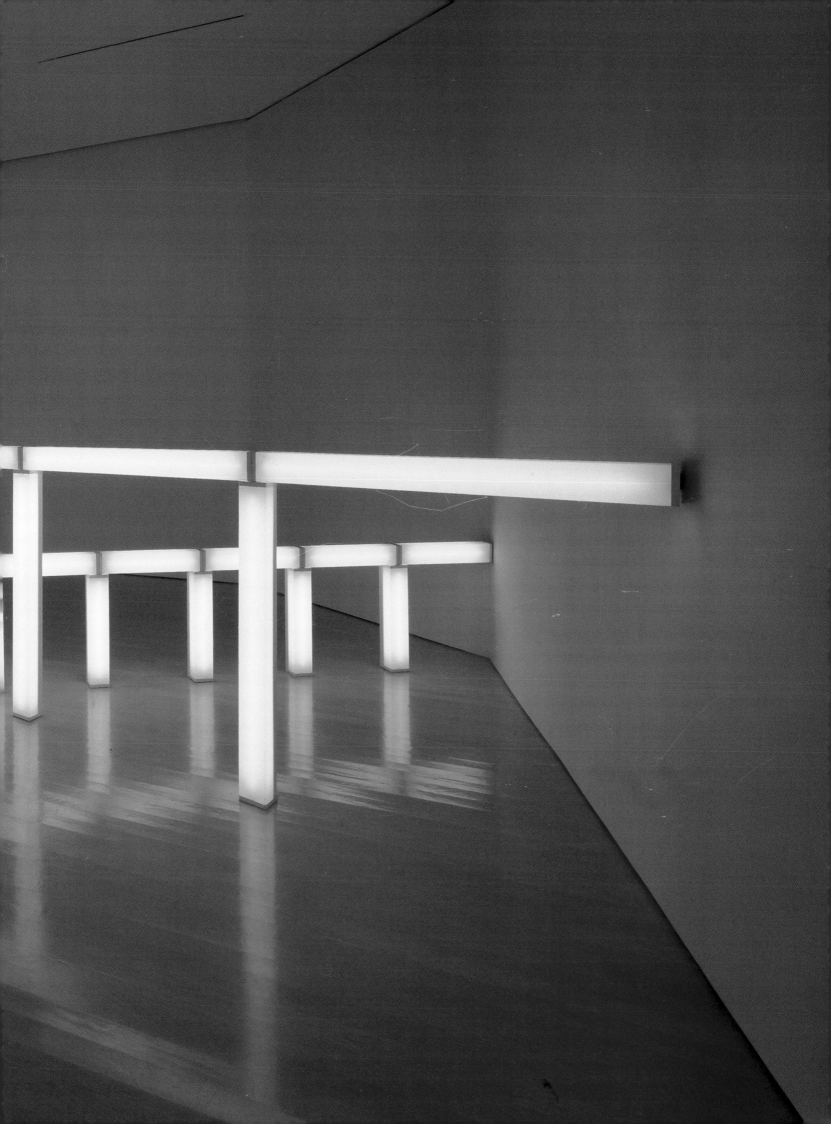

an artificial barrier of blue, red and blue fluorescent light (to Flavin Starbuck Judd), 1968

Brydon E. Smith

Dan Flavin is best known for his creative use of fluorescent light—in small, individual pieces as well as in large installations for a variety of both preexisting and specially constructed spaces, or "situations," as he preferred to call them. Flavin did not begin his career with fluorescent light as his preferred medium of expression, rather, he began in a traditional way working with standard mediums until as late as 1961. It wasn't until the mid '60s that he began transforming interiors with various configurations of colored fluorescent light—a change that was nonetheless radical for the slow, methodical way it came about.

In work from the late '50s, such as *blue trees in wind* and *the act of love*, Flavin depicted a range of subjects by covering sheets of paper with energetic pencil lines and sensuous washes of watercolor. Around 1960, he took objects he had picked up on the street, covering their surfaces with a thick layer of paint and arranging them in small constructions, like the single crushed can in *Apollinaire wounded (to Ward Jackson)*, 1959–60. In more intimate works, he illuminated hand-written poems by James Joyce, as in *Chamber Music I, nos. 1–7 (to James Joyce)*, 1959, and verses from the Old Testament, as in *Song of Songs*, 1959.

Flavin began making notes for an electric-light art in the spring of 1961, while a guard at the American Museum of Natural History. In October of that year, he wrote a short poem, centered vertically on a sheet of paper, about fluorescent light (see p. 48). As he suggests in his poem, Flavin remarked in conversation some years later that when his fluorescent pieces were turned off they were no longer art.

In late 1961, Flavin began to attach store-bought, electric-light fixtures to the sides of small, square-fronted, wooden constructions, smoothly painted in one color. The combination of paint and light together intrigued him, and he liked to contemplate the mix of the two sources of colored light—one reflecting from the painted surface of these constructions and the other emanating directly from the incandescent bulbs and fluorescent tubes attached to them. By the end of 1961, Flavin had attached a two-foot-long fluorescent fixture along the top of his first construction, or "icon," as he descriptively called each of these works in this series of eight. It was not until May 25, 1963, however, that he felt sufficiently well-founded in his use of light, specifically fluorescent light, to attach a single, eight-foot fixture with a yellow tube to his studio wall at a 45-degree angle. Somewhat romantically, he declared this piece to be "the diagonal of personal ecstasy," before he later retitled it. Although Flavin was at first unsure how others would understand the work as art, he saw its potential as both light and material object. He wrote, "Now the entire interior spatial container and its components—wall, floor, and ceiling—could support a strip of light but would not restrict its act of light except to enfold it. Regard the light and you are fascinated—practically inhibited from grasping its limits at each end."[1] The following year, Flavin confidently put his new medium into the public domain in a pair of one-man shows in New York. The first, called *some light*, opened in March 1964 at the Kaymar Gallery. It featured the "icons" and a few fluorescent pieces. The second, called *fluorescent light*, opening in November, 1964, at the Green Gallery. It featured an ensemble of six individual fluorescent pieces attached directly to the gallery walls and, interestingly, a seventh piece placed on the floor with its tubes pointing upward. Flavin realized that "the actual space of a

room could be disrupted and played with by careful, thorough composition of the illuminating equipment." This was particularly true of the second exhibition, in which he had carefully positioned some of the works in relation to the corners and edges of walls. This served both to frame the lights themselves and to draw attention to the architectural features of the surrounding space. Flavin also realized, however, that this pair of exhibitions left him mainly "at play on the structure that bounded a room but not yet so involved in the volume of space, which is so much more extensive than the room's box."

In March 1965, Flavin finally ventured into the interior of the exhibition space, in a show at the Institute of Contemporary Art, Philadelphia. By positioning one fluorescent fixture on a diagonal from a wall onto the floor and by projecting another one horizontally into the room from the arch of the entranceway, Flavin positioned the light source in the space of the room itself. This also served to emphasize the physical aspects of the fluorescent fixtures, thereby "bringing the lamp as image back in balance with it as an object," as Flavin later wrote. He was now just a year away from planning special installations that would fill entire rooms—with fluorescent fixtures extending across the room physically and with their light suffusing the remaining space. These structures acted as barriers by restricting the viewer's movement.

Flavin built his first "barrier" piece, entitled *greens crossing greens (to Piet Mondrian who lacked green)*, for the *Kunst Licht Kunst* exhibition in the Stedelijk van Abbemuseum in Eindhoven, Holland, in September 1966. In this installation, Flavin boldly bisected an octagonal gallery with two fence-like structures that crossed from wall to wall in two directions, dividing the floor space into four sections. As the title indicates, he used only green light, because it's a pleasant color yet it's brilliant enough to fill an entire room. From that moment on, Flavin never looked back.

Flavin's second barrier piece, *an artificial barrier of blue, red and blue fluorescent light (to Flavin Starbuck Judd)*, beautifully brought more color into play and strengthened the structural element by overlapping rectangular modules constructed from fluorescent fixtures, each about two-feet high and four-feet wide. This low and fairly dense barrier—with its horizontal, four-foot-long blue tubes facing up, and its vertical, two-foot-long red tubes facing left and right—was stretched across a room from wall to wall in the *Minimal Art* exhibition at the Gemeentemuseum, The Hague, March 1968. Flavin dedicated the piece to Donald Judd's two-month-old first child, whom Judd had named after Flavin.

It is interesting to know that Flavin admired Judd as a colorist, particularly his use of intense red in the early '60s, and that he liked this barrier because of its strong color and its basic structural soundness. Blue and red fluorescent light have complex effects on one another: the blue light diffuses freely through the surrounding space and serves to restrain the red somewhat by making the illuminated red tube appear darker. The blue and red light also blend subtly in the space around the barrier, yielding an overall violet effect. While much positive critical acclaim has been directed, rightly, at the straightforward structural aspects of Flavin's work, what I like most is his accomplishment as a sensuous colorist of real space who mixes different quantities and colors of fluorescent light right before your eyes. For me, the experience of a piece like this barrier is a vivid reminder of just how beautifully Dan Flavin's electric-light art continues to glow.

PLATE 4
*an artificial barrier of blue, red and blue
fluorescent light (to Flavin Starbuck Judd)*, 1968
Fluorescent light fixtures with blue and red lamps
2 and 4 ft. fixtures; 66 x 1419.9 x 22.9 cm
(26 x 559 x 9 inches) overall
Solomon R. Guggenheim Museum, New York,
Panza Collection, 91-3707

1. All quotes are from ". . . in daylight or cool white" by Dan Flavin, in *Dan Flavin: fluorescent light, etc,* exh. cat., National Gallery of Canada, Ottawa, 1969, pp. 19–20.

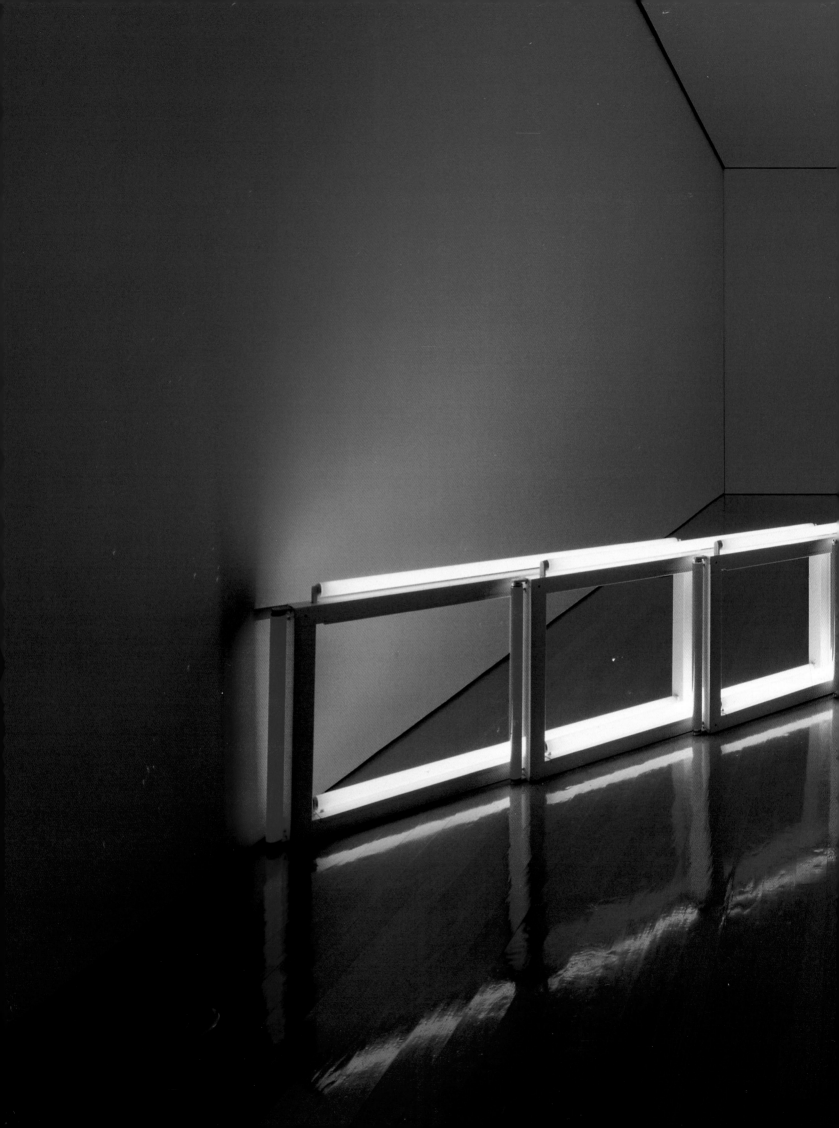

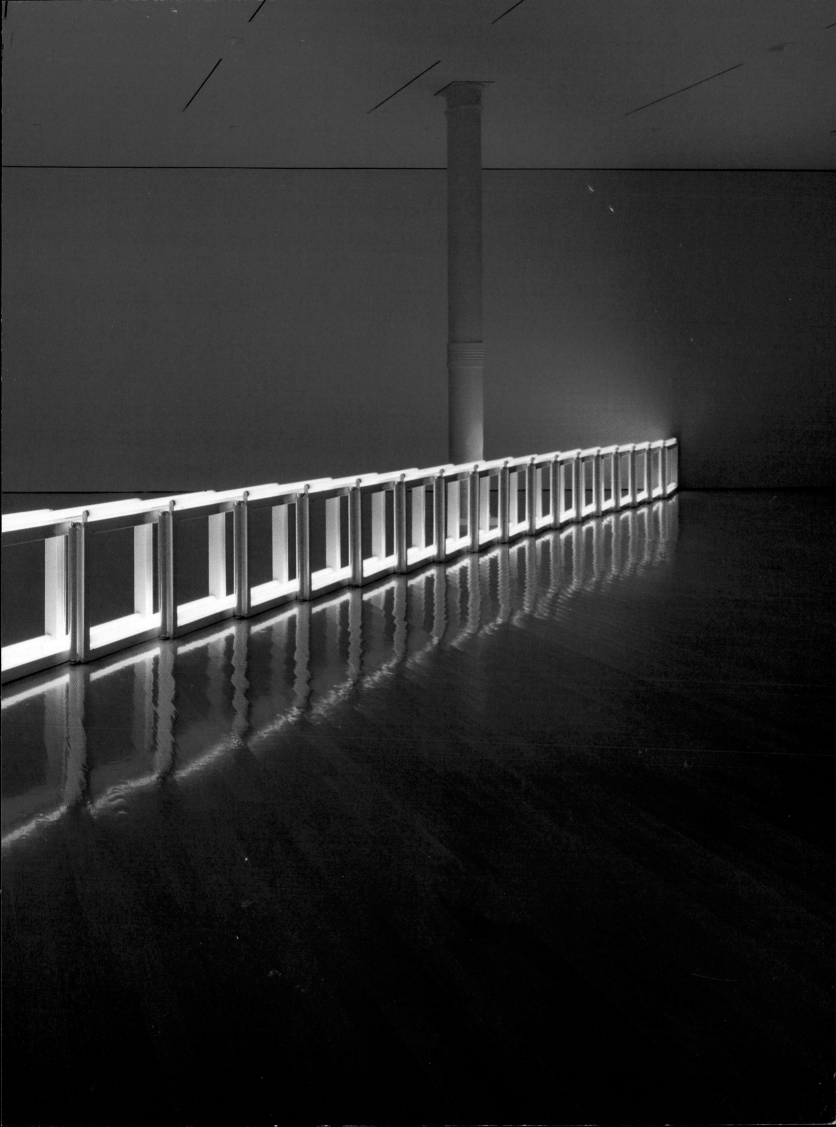

untitled (to Jan and Ron Greenberg), 1972–73

Jonathan Crary

Dan Flavin's work, dependent as it is on mural surfaces, has long been understood through its crucial overlap with the problem of architecture. His art-historical significance in large part has turned on how he emphatically severed the experience of luminosity from pictorial conditions and lodged it within lived, environmental relations—that is, within the architectural realities of his various exhibition spaces. When discussing Flavin and other Minimalists, however, we have become so habituated to categorical simplifications that we often bypass the intellectual complexity and internal paradoxes of the works themselves. In a piece like *untitled (to Jan and Ron Greenberg)*, 1972–73, for instance, Flavin seems aware that even as his work in the late '60s had disclosed a new unboundedness of color and light, it does not completely liberate the viewer from older models of visual and aesthetic experience. The richness of *untitled (to Jan and Ron Greenberg)*, derives from Flavin's sensitivity to the heterogeneous yet historically sedimented nature of perception and its constitutive relation to architecture.

Flavin's practice vividly breaks with a perspectival conception of how light functions and produces aesthetic effects, but at the same time the "corridor" structure of the work locates us within an architectural space that can only be described as perspectival. The corridor necessarily establishes a three-dimensional cubic interior defined from the viewer's perspective by orthogonals, the lines where the faces of the cube meet. These lines, which we know well from classical Renaissance perspective, allow the viewer to apprehend recessional extended space; if continued indefinitely, these lines would appear to meet at a vanishing point—a hypothetical juncture, which Flavin of course excludes from the work. Flavin deploys his chromatic effects within a residual framework of classical, representational conditions at the same time that he disrupts the subject and object positions of the perspectival system.

The tension generated by conflicting, even irreconcilable, expectations and actualities resonates within this and other related corridor pieces. The architectural configuration fundamentally perpetuates an aesthetics of *distance*, in which the observer's relation to the artwork is figured as a conical beam of light rays that corresponds to the orthogonals of the exhibition space. Flavin's "barrier" of vertically aligned fluorescent tubes in this sense takes on a pictorial identity as a plane that intersects the visual cone, in the manner first described by Leon Battista Alberti in the fifteenth century. This relation of distance between observer and object was what Walter Benjamin identified as the basis for "auratic" art. While it is certainly not coincidental that Flavin's radical reimagining of aura engages the paradoxes of subjective distance, it is important to remember that his work from the early '70s coincides with the early stages of global technological modernization, in which a primary experience of light as illumination is displaced by light as depthless, placeless flows of abstract information. Flavin provides a distillation of larger social experiences of the de-symbolization of luminosity.

In terms of the long trajectory of visual modernism since the late nineteenth century, Flavin is heir to the optical project of Georges Seurat and Neo-impressionism. Seurat, in his technocratic rationalization of optical processes, performed a momentous shift and made the art work itself into a producer of chromatic and luminous experience. Marshall McLuhan recognized the consequences of Seurat's transformation of

painting into a light source: space could no longer be considered neutral, an empty container to house the discrete, autonomous object. Instead the viewer and his milieu became active, charged, constituent forces in a field of irradiative and vibratory events. It is nonetheless an arrangement in which traditional pictorial expectations provide a background for their eventual nonfulfillment and repudiation.

Flavin's use of light occurs fully outside of a *punctual* model of optical phenomena, in which light rays, with a directional identity, emanate like a beam from one point and illuminate another point. This punctuality is inherent in perspectival systems of visual representation, especially in the way in which a point-to-point setup establishes a relatively stable and coherent subject position. It is, however, the directionless quality of Flavin's light—light as an enveloping, immeasurable, and ubiquitous environment—that determines the sensory and psychological impact of his work. It is this nonlocalizable saturation that dissolves the possibility of Benjamin's auratic distance. Here, the familiar phenomenological readings of Flavin's work also prove inadequate. While phenomenology sought to preserve the rootedness and stability of the individual observer in relation to a primal horizon against which unconditional perceptual meanings could arise, the omnipresence and formlessness of Flavin's luminosity eradicate the coherence of such an orienting horizon.

In *untitled (to Jan and Ron Greenberg)*, the apparently planar field of fluorescent tubes oscillates between its status as an opaque obstacle that prevents us from seeing or walking beyond it and its status as a dematerialized pool of light, impalpable and incandescent. The unmediated presence of light, which signifies nothing other than its own energy and the revelation of its own immediacy, operates in a play of disclosure and concealment. Flavin's decisive gambit, however, is to disallow this possibility of pure luminous presence by leaving a narrow vertical aperture onto a space and a glimmering radiance *beyond*. The effect of a totalizing monochromatic field is inflected by this indication of transitiveness, of a looking *through*. The chromatic contamination of this peripheral emanation, of this exterior glow, however, is hardly the indication of a privileged and inaccessible source of light. Rather, within Flavin's architectural schema, the vertical aperture becomes the hinge of the work's logic of exchangeability and duplication. Our own perception of the piece is inseparable from an ambulatory experience of its chromatically distinct but otherwise identical faces, which ceaselessly fold in on one another, like a Duchampian structure of reversibility. Flavin permits nostalgia for the transcendence of pictorial space but keeps us situated in a world of material operations and procedures.

PLATES 5 and 6
untitled (to Jan and Ron Greenberg), 1972–73
Fluorescent light fixtures with yellow and green lamps
Edition 1 of 3
8 ft. fixtures; 243.8 x 210.8 x 22.9 cm
(96 x 83 x 9 inches) overall
Solomon R. Guggenheim Museum, New York,
Panza Collection 91.3708

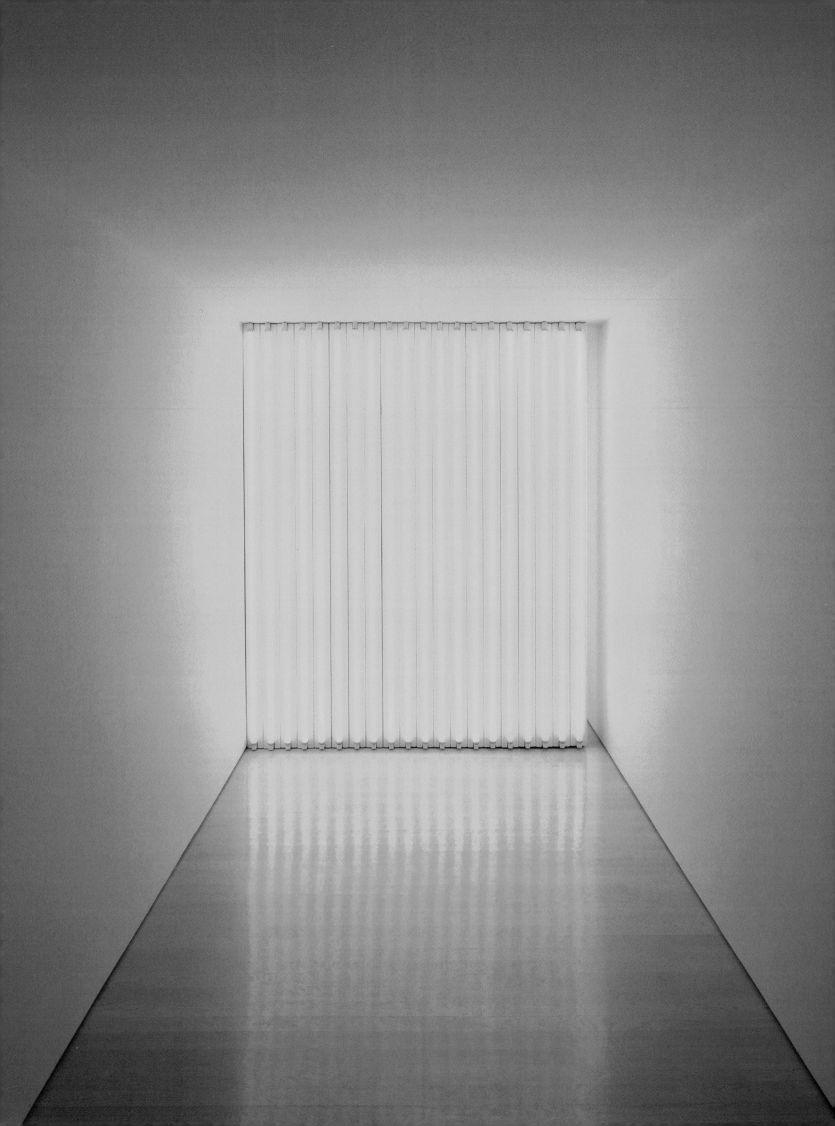

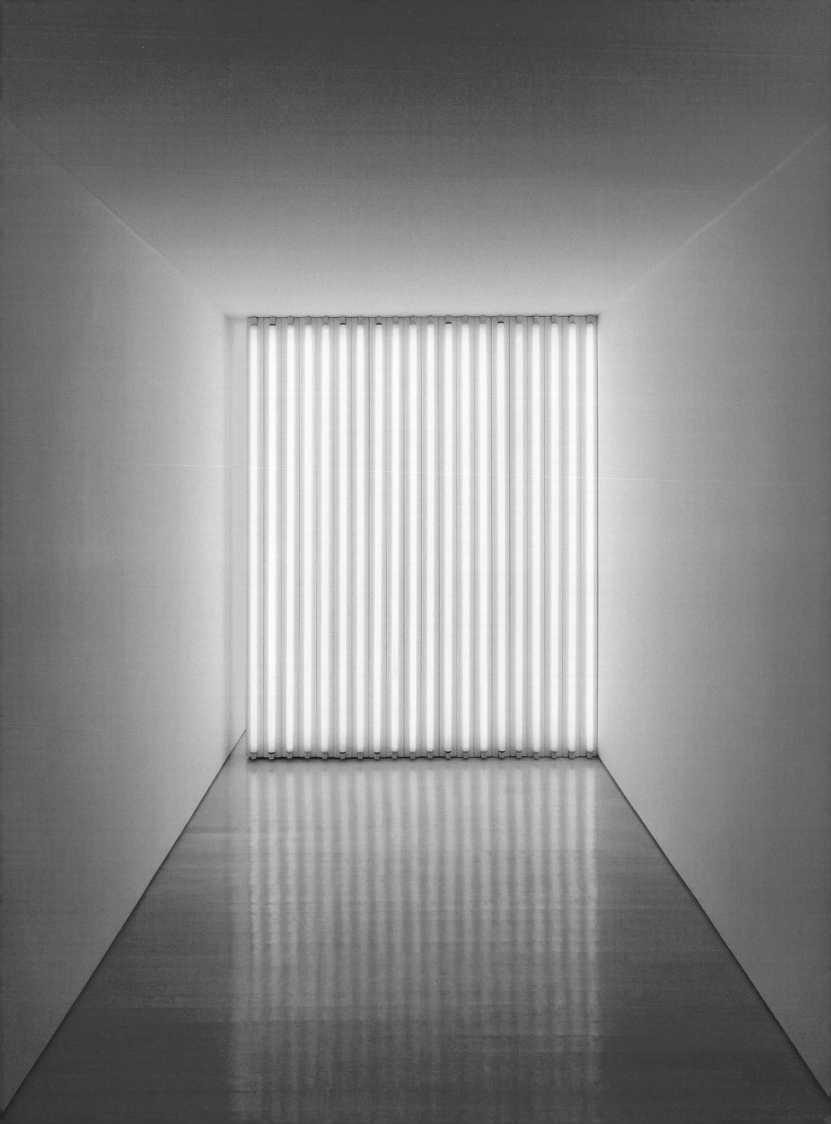

untitled (fondly to Margo), 1986
Tiffany Bell

This exhibition includes two of seven related works called *untitled
(fondly to Margo)*, which Dan Flavin originally installed in 1986 at the
Margo Leavin Gallery in Los Angeles. Flavin often grouped similar-
looking works in a single show as he did at Leavin's gallery: he would
make several works play out a progression of colors or arrangement of
fixtures, for instance; or he would make a single composition in different
colors. Sometimes the resulting series followed a definite, complete pat-
tern. Sometimes the works were more loosely ordered, as in the case of
the "Margos."

This "progressional procedure" was one aspect of Flavin's work that
characterized it as Minimal art.[1] Other Minimalists, such as Carl Andre
and Donald Judd, used a similarly predetermined, systematic approach.
The order and repetition that resulted distinguished their art from the
Expressionistic, seemingly spontaneous gestures of the previous gen-
eration of artists, and thus took on significance in regard to a range of
relevant issues of the period—handmade versus industrial production,
the nature of individualism, the importance of a part to the whole, and
so on.

Flavin also solved a more pragmatic problem by establishing these
systems. As a new art medium, electric light was not imbued with
aesthetic conventions for Flavin to work with and against. It did carry a
certain mundane and utilitarian reference but offered no precedent for
formal artistic presentation. By projecting a system—or many systems
within a larger one—Flavin provided himself with a structure and was
able to work with it and in opposition to it. By so doing, he generated
a sense of conflict, irony, or humor—in contrast to the expectation and
logic generated by the proposed order.

In fact, Flavin predicated the entirety of his work with electric lights
on a ready-made system of industrially produced fluorescent fixtures and
colored lamps. Fluorescent lamps are available only in a limited range
of colors and sizes. Straight tubes come in pink, green, yellow, blue, red,
and four shades of white. Four lengths are most readily available—two-
feet, four-feet, six-feet, and eight-feet. Circular fluorescent lamps, with
occasional exceptions, are made in the four kinds of white. All Flavin's
light works are based on the possibilities and limitations of these
variables. In a well-known quotation, Flavin acknowledged his systematic
approach, recognizing the repetition and consistency inherent in his
chosen medium and compounded by his own use of it. He wrote:

> I know now that I can reiterate any part of my fluorescent light
> system as adequate. Elements of parts of that system simply alter
> in situation installation. They lack the look of history. . . . All my
> diagrams, even the oldest, seem applicable again and continually.[2]

The variety and differentiation of the pieces depend on modifications
made in contrast to the established pattern and/or the specific situation
of the installations. For instance, six of the seven "Margos," including
the two in this exhibition, adhere to a loose system based on the possi-
ble ways of pairing two long banks of pink and yellow lights. Though
made from standardly produced lamps, these works are unusual in
Flavin's oeuvre because the backs of the fixtures are triangular volumes
instead of the rectangular, flat-backed ones more commonly associated
with his work. When placed on the wall, the lamps cantilever off it.
Nonetheless, the compositional strategies are consistent with those

PLATE 7
untitled (fondly to Margo), 1986
Fluorescent light fixtures with yellow and pink lamps
Edition 1 of 3
8 ft. fixtures; 259.1 x 243.8 x 21.3 cm
(102 x 96 x 8³/₈ inches)
Panza Collection, Gift to Fondo per l'Ambiente Italiano,
1996, on permanent loan to the Solomon R.
Guggenheim Foundation, New York 200.93

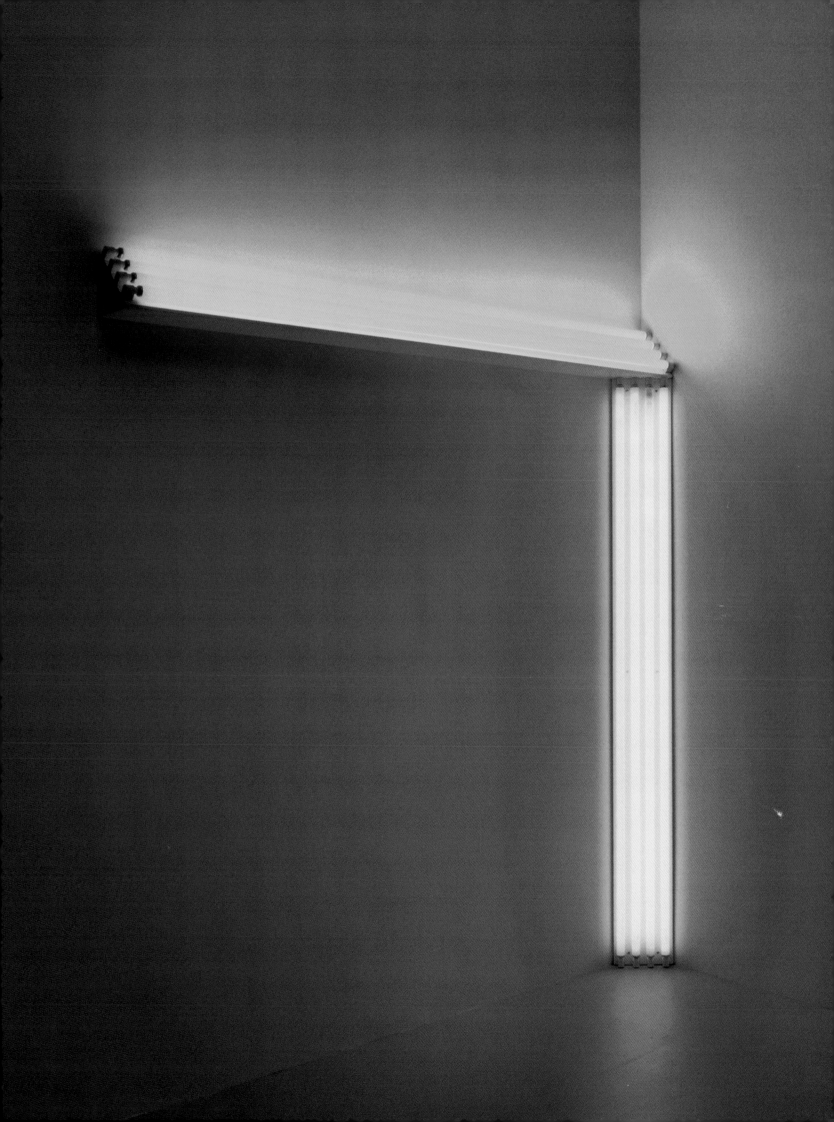

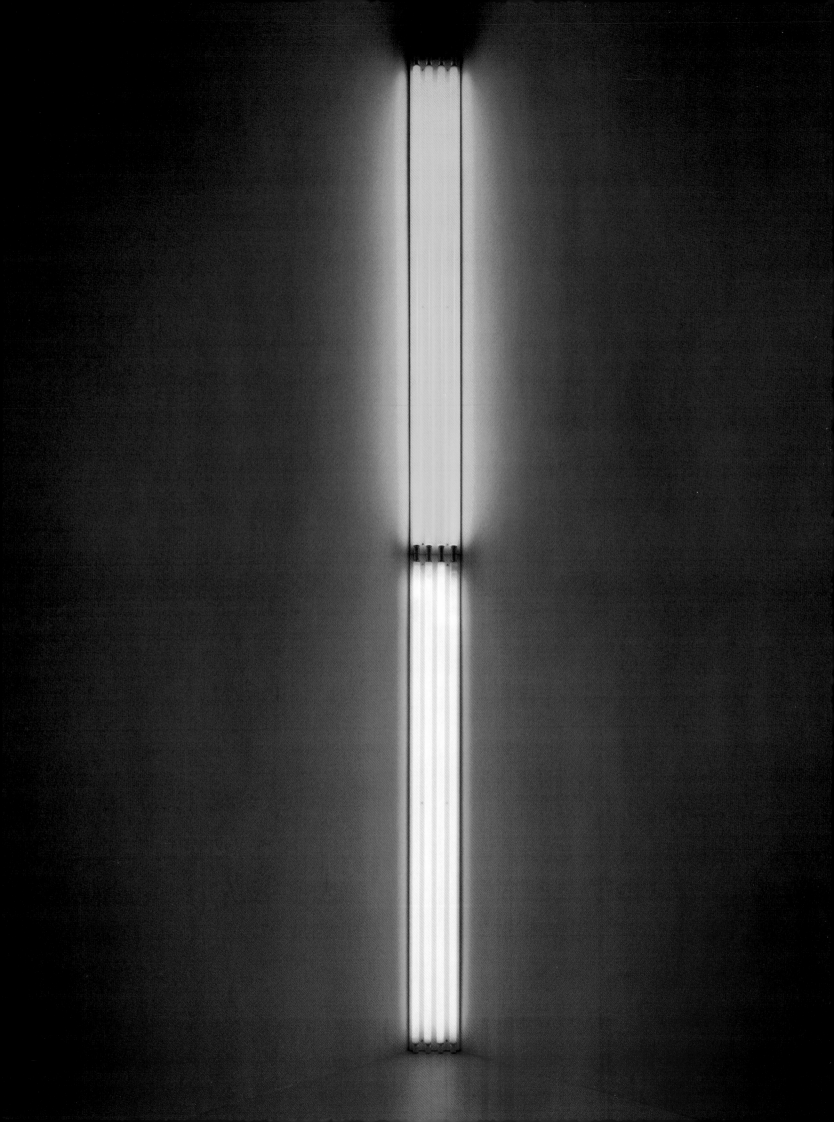

Flavin used earlier. Each fixture supports four eight-foot-long lamps. In all six works, he placed a bank of pink lights below or next to a bank of yellow lights. Sometimes stacked, sometimes arranged horizontally apart or vertically together, and sometimes set at a 90-degree angle, they all use architectural surfaces—the floor, the wall, the ceiling, and the corners. Sometimes they face toward each other and sometimes away. Seen as a group, or even paired like the two works in this show, they relate to each other, the configuration of one accounting for that of another.

The seventh "Margo," however, is an anomaly. It is made of three shades of white light with an eight-foot-long fixture that faces into the corner and supports four two-foot-long verticals and four circular lamps that face out. By making this work part of the group, Flavin breaks the system, calling attention to it at the same time that he directs attention to other aspects of the work, besides its serial composition.

In considering the original installation, Flavin's intention becomes clear. The large scale of the six pink and yellow works responded to the large, open room. One imagines that the serial aspect of the work would have unified the viewing experience, and that the compositional differences would have activated and transformed the space. Pink and yellow, a bright and garish combination of fluorescent lights, were colors Flavin associated with the gaudiness of Los Angeles.[3] The seventh "Margo," however, illuminated a second, smaller room. While still quite decorative and whimsical in the context of Flavin's work, the more sub-dued, natural white light would have highlighted the decorative quality of the pink and yellow room by providing a contrasting experience. Each piece could certainly function independently—articulating a corner, defining a segment of a room, or illuminating a situation—but together each one builds upon the experience of the others, introducing com-plexity and potential into the understanding of each individual piece. As such, the "Margos" are a microcosm of Flavin's entire system of lights.

1. See Mel Bochner, "Serial Art, Systems and Solipsism," in Gregory Battcock, ed., *Minimal Art*, New York, 1968, p. 99. Bochner credited Flavin with being "one of the first artists to make use of a basically progressional procedure."
2. Dan Flavin, "some remarks . . . excerpts from a spleenish journal," as published in *Dan Flavin: three installations in fluorescent light/Drei installationen in fluoreszierendem licht*, exh. cat., Wallraf-Richartz-Museums and Kunsthalle Köln, 1974, p. 90. Originally published in *Artforum* (Los Angeles) 4, no. 4 (December 1966), pp. 27–29.
3. See Dan Flavin and Emily Rauh, *drawings and diagrams 1963-1972 by Dan Flavin*, The Saint Louis Art Museum, Mo., 1973, p. 60; and Dan Flavin and Emily Rauh, *corners, barriers and corridors in fluorescent light from Dan Flavin*, The Saint Louis Art Museum, Mo., 1973, p. 38.

untitled (to Barbara Nüsse), 1971
Michael Newman

Installations of Dan Flavin's "proposals" are hard to reproduce: at once too remote from the photograph, as they are made possible by reflected rather than radiant light and burned out by the glare of the fluorescent tube; and too close, in that they enunciate their situation, as indexical signs. This latter aspect extends the performative dimension of Barnett Newman's "zip" paintings.[1] While the presence of Newman's paintings is supposed to be that of the origin, however, the presence of Flavin's installations relies on their duration[2]—limited by the life of the tube, which can also be switched off. Flavin's treatment of the ready-made in the form of commercial fluorescent lighting introduces the trace of technology into the experience of the work, while relating to an immediate and not a representational presence. The paradox of Flavin's work is this combination of mediation and immediacy, of technology and effulgence.

Untitled (to Barbara Nüsse), 1971, comprises two short fluorescent lights in a cruciform configuration, installed in a corner at approximately head height, with a vertical pink tube that faces into the corner and a horizontal blue one that faces the viewer. The pink light casts onto the wall an elongated form with "arms," and by filling the space between the lighting units and the corner creates the sense of an interior. By contrast, the horizontal blue acts like a barrier, closing off access into this interiority—all the more so since the viewer has to look into its glare to see the pink, which is fringed with purple as it comes into the range of the blue.

Flavin's use of standardized fluorescent light fixtures rather than malleable neon may indicate a refusal of any overtly iconic or symbolic sign. The early series of "icons" (1961–63),[3] monochrome paintings with light fixtures attached to their edges, is the exception that proves the rule, since the icon is a sign that exceeds its limits as a resemblance. On the one hand, the "Greek cross" configuration of *untitled (to Barbara Nüsse)* may remind us of the one that characteristically appears in the halo of Christ, suggesting jets of radiance. Adolphe Didron in his *Christian Iconography* reminds us that "the aureole and the nimbus are identical in their nature, which is that of a transparent cloud or a solid light."[4] On the other hand, the head of the Redeemer is absent, as is any otherworldly redemption: we confront a light that is manufactured— not that of the stained-glass window of the church, but of the corporate office and corridor, and of functional public spaces.[5]

The source of Flavin's corner installations—*untitled (to Barbara Nüsse)* among them—in Tatlin's *Corner Reliefs* of 1915 is well known. No doubt Flavin was also aware of Malevich's *Black Square* of 1915, which was originally hung high in a corner like an icon. These works of Tatlin and Malevich represent contrasting possibilities of the avant-garde, an intervention in real space that draws attention to the factual characteristics of its materials or the effacement that is the prelude to an entirely new, transcendent space, which erases the religious art upon which it depends for its meaning. Effectively, in corner installations such as that of 1971, Flavin has elaborated on the contradiction between these two modes.

By means of fluorescent light, Flavin established a connection between opposing terms: the literal and the icon. The light of the icon is not a light that indirectly illuminates a scene to be represented, but one that radiates through the object itself. In no sense, though, do Flavin's works represent a religious subject matter. Rather, Flavin's fluorescent-light

works establish an analogical relation with the ontological status of the icon as sign: in their use of an emanating light that overflows limits; in the implication that they are "uncreated"; and in the performativity that invites a bodily relation to the object. In Flavin's work, however, the light emanates not from God but from a mass-produced fixture, and it is not intended to invite veneration. The identity between the terms that makes the analogy possible and justifies it is precisely what makes Flavin's installations unreproducible: the hidden mediator between Flavin's fluorescent-light installations and the Byzantine icon is the photograph, which shares the indexicality of both.[6] The analogy of installation and icon is in fact based on their common nonidentity with the photograph. Furthermore, the difference in the way each is respectively not a photograph marks the unbridgeable historical gulf between them.

The corner positioning is essential to the tension of *untitled (to Barbara Nüsse)*. In 1968 Flavin wrote the following of his exhibition *cool white, etc.*, at the Dwan Gallery: "The corner installation was intended to be beautiful, to produce a color mix of a lovely illusion, to render the wall junction above the 'fact' of the floor triangle less visible than in usual lighting."[7] The effect of a fluorescent light turned to the corner, particularly a colored light like the one in *untitled (to Barbara Nüsse)*, is to dissolve the articulation of the angle of the room (opposite to both Tatlin's emphasis of it and the homology between rectilinear object and room-container set up in other Minimalist work). This is combined with the blinding effect of the blue horizontal strip turned toward the viewer. The phenomenal effect of the work exceeds its literal conditions. A "religious" reading, which would render this excess positive and affirmative, would be belied by Flavin's own statement of 1962: "My icons differ from a Byzantine Christ held in majesty; they are dumb—anonymous and inglorious. . . . They are constructed concentrations celebrating barren rooms. They bring a limited light."[8]

This brings us, finally, to a speculative answer to the question of why *untitled (to Barbara Nüsse)* should have been dedicated to a German actor.[9] Flavin's dedications to friends and acquaintances may be seen as another way in which he marked the points at which public and private intersect. We do not know precisely why Flavin dedicated this "cross" to Barbara Nüsse. Yet there is one characteristic the fluorescent installation shares with any actor: performativity. Michael Fried's notorious condemnation of "literalist" (Minimal) art was ultimately based on a relation of the experience of art to time that he described as "theatrical." Opposed to the "presentness" of Modernist art is "the literalist preoccupation with time—more precisely, with the duration of the experience—[which] is . . . paradigmatically theatrical: as though theatre confronts the beholder, and thereby isolates him, with the endlessness not just of objecthood but of time; or as though theatre addresses a sense of temporality, of time both passing and to come, simultaneously approaching and receding, as if apprehended in an infinite perspective."[10] This does not quite fit Flavin's work, which is not simply literalist, but rather concerns the difference between the literal and that which exceeds it. Nor does his work, however, furnish the Modernist illusion of full presence. The latter is "alienated" in quite a Brechtian way: Flavin's appropriation of a ubiquitous but specific ready-made fixture shows the works' dependence on historical conditions. Flavin's response to the ready-made is the negation of the ready-made's negation of function—after all, it still lights the room. As art, however, this negation of negation doesn't produce a positive use value, but rather what we could call a "performance." Such a performance is reflexive, referring to its own conditions of

possibility, yet at the same time exceeding its context. So we have to qualify the Brechtian reading. Just as the paradox of the actor lies not in that she becomes the character, but that in acting she both is and is not the character,[11] so the hint of the utopian in Flavin's work lies not in transcendence as such, but in the difference between the literal and its excess. What is delimited thereby is limitation itself, but without positing the unlimited in any ahistorical sense.

1. See Yve-Alain Bois, *Painting as Model* (Cambridge, Mass.: The MIT Press, 1990), p. 193.
2. Ibid, p. 213.
3. Illustrated with related drawings and notes in *fluorescent light, etc. from Dan Flavin*, exh. cat., National Gallery of Canada, Ottawa, 1969.
4. Adolphe Napolèon Didron, *Christian Iconography; or, The History of Christian Art in the Middle Ages*, Vol. 1, trans. Margaret Stokes (London: George Bell and Sons, 1886), p. 107.
5. For a discussion of the history of recent art in terms of the politics of public space, see Frazer Ward, "The Haunted Museum: Institutional Critique and Publicity," *October* 73 (summer 1995), pp. 71–89.
6. For a comparison of the icon with the photograph, see Hans Belting, *Likeness and Presence: A History of the Image before the Era of Art*, trans. Edmund Jephcott (Chicago: University of Chicago Press, 1994), p. 53.
7. From a discontinued letter of November 6, 1968, to Philip Leider, reproduced in *fluorescent light, etc. from Dan Flavin*, p. 238.
8. Quoted ibid, p. 176, a statement in a record book dated August 9, 1962. First published in "'. . . in daylight or cool white': an autobiographical sketch," *Artforum* (Los Angeles) 4, no. 4 (December 1965), pp. 21–24.
9. According to Heiner Friedrich, as reported to me by Fiona Ragheb, Flavin knew Barbara Nüsse personally, and met her several times in Germany.
10. Michael Fried, "Art and Objecthood," *Artforum* (New York) 5, no. 10 (summer 1967), pp. 12–23. Reprinted in *Minimal Art: A Critical Anthology*, ed. Gregory Battcock (Berkeley: University of California Press, 1995), p. 145 (italics in original).
11. See Dennis Diderot, *The Paradox of Acting*, intro. Lee Strasberg and trans. Walter Herries Pollock (New York, Hill and Wang, 1957), p. 16. I thank Phoebe von Held for this reference.

PLATE 9
untitled (to Barbara Nüsse), 1971
Fluorescent light fixtures with blue and pink lamps
Edition 8 of 50
2 ft. fixtures; 61 x 61 x 22.9 cm
(24 x 24 x 9 inches)
Solomon R. Guggenheim Museum, New York,
Panza Collection, Gift 92.4118

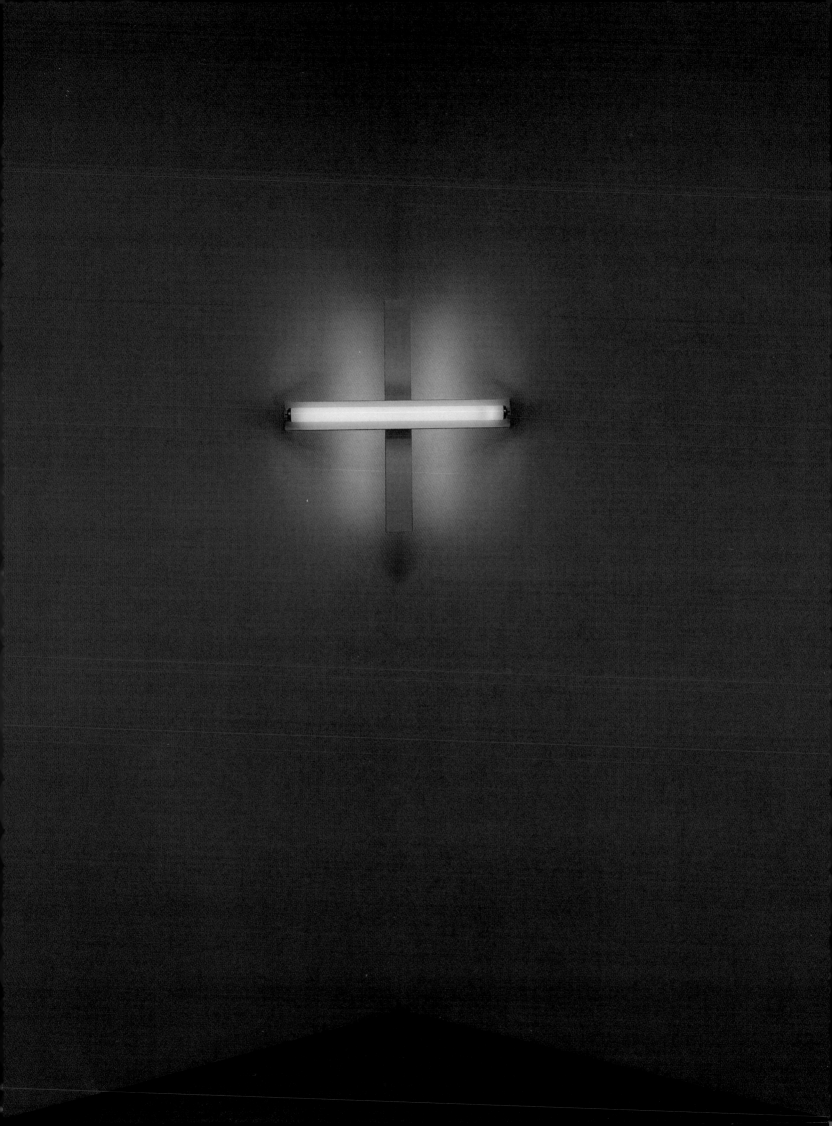

Writings
Dan Flavin

about most of my published writings . . .

Most artists who write are accused of concocting and dispensing self-serving prose, that is, writing and publishing periodically about their arts. Well, my usage was consistent with that accusation—and, even now, I'm not ashamed about it. After all, I sense that I tried to tell somewhat, to contest, too, for personal openness and freedom as seemingly possible and to entertain a bit, however bitterly. But I've written otherwise than about my arts but the previous comments would bear there, too. Looking over so much of it again (and that's annoying with so much temporary commentary gone old), I've found that most of what I have had issued has been about the thought of and context for contemporary arts first, in America and then, elsewhere. This applies even to my elect nagging nonsense, steadily opposing insistently absurd and presumptuous culturally protective corrective summary journalistic art criticism, that conclusively "commanding" ever ready opinionating for each editorial deadline in print on pulp. I hope that this elaborate appended accumulation, mostly of publications or intended ones since 1961, can become informative and enjoyable for each of you now. I still believe in quite a lot of it and can laugh again.

(1973)

untitled, 1963 (detail)
Fluorescent light fixture with green lamp
Edition 1 of 3
8 ft. fixture; 243.8 x 10.2 x 12 cm
(96 x 4 x 4¾ inches)
Solomon R. Guggenheim Museum, New York,
Panza Collection, Gift 92.4112

fluorescent
 poles
 shimmer
shiver
flick
 out

 dim

monuments

of
 on
 and
 off

 art

(October 2, 1961)

untitled (to Henri Matisse), 1964 (detail)
Fluorescent light fixture with pink, yellow,
blue, and green lamps
Edition 2 of 3
8 ft. fixture; 243.8 x 25.4 x 12.7 cm
(96 x 10 x 5 inches)
Solomon R. Guggenheim Museum, New York,
Panza Collection, Gift 92.4113

". . . in daylight or cool white."
an autobiographical sketch

*(to Frank Lloyd Wright who advised Boston's "city fathers" to have
a dozen good funerals as urban renewal)*

". . . we might, if, like the things outside us we let the
great storm over-ride us, grow spacious and anonymous."
—Rainer Maria Rilke

"It looks like painting is finished."
—Don Judd

"Dan Flavin has destroyed electric lights for me. I'm going
back to candles."
—Tom Doyle

My name is Dan Flavin. I am thirty-two years old, overweight and under-
privileged, a Caucasian in a Negro year.

I was born (screaming) a fraternal twin twenty-four minutes before
my brother, David, in Mary Immaculate Hospital, Jamaica, New York, at
about seven in the morning on a wet Saturday, April Fool's Day, 1933,
of an ascetic, remotely male, Irish Catholic truant officer whose junior
I am, and a stupid, fleshly tyrant of a woman who had descended from
Bavarian royalty without a trace of nobility.

Early, I was the victim of a substitute mother, an English "nanny,"
fraught with punctilious schedules, who tried to toilet-train me at two
weeks of age. When she failed or I failed, she slapped me.

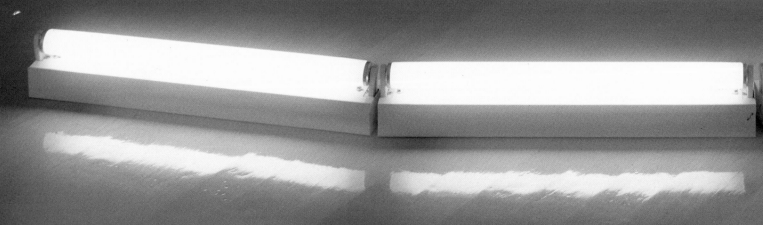

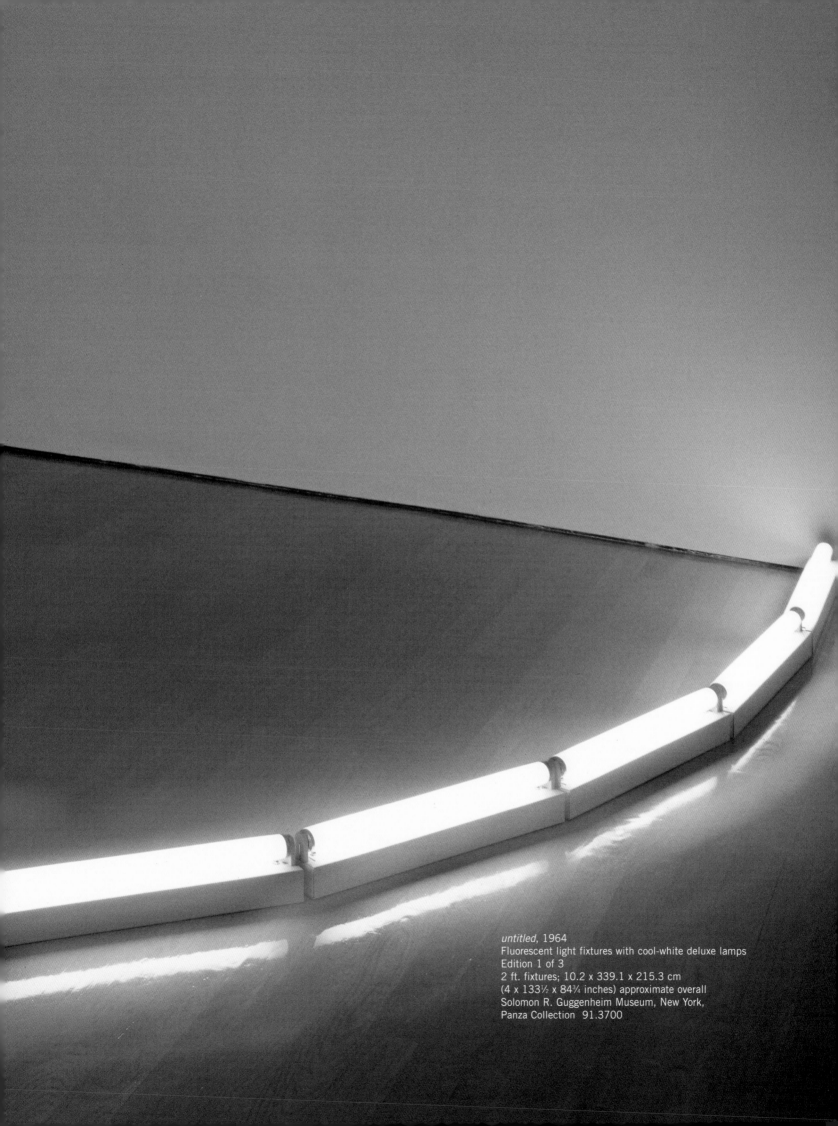

untitled, 1964
Fluorescent light fixtures with cool-white deluxe lamps
Edition 1 of 3
2 ft. fixtures; 10.2 x 339.1 x 215.3 cm
(4 x 133½ x 84¾ inches) approximate overall
Solomon R. Guggenheim Museum, New York,
Panza Collection 91.3700

Before I was seven, I attempted to run away from home but was apprehended by a fear of the unknown just two blocks from our house.

I started drawing by myself as a small boy. (My mother told me that I had made a vivid, if naïve, record of hurricane damage on Long Island in 1938.)

"Uncle Artie" Schnabel, the vice-president of my father's East River boat club, became my first instructor in art. He was a portly, ebullient, red-faced old World War veteran, whose battered left leg bore a brace and pained him gravely when it was about to rain. Also, he had been gassed. I saw his Purple Heart.

On a certain sunny Sunday afternoon, dockside on the river, he set aside a stein of beer, adjusted his glasses, and showed me how to put down pencil water around a ship by lightly dappling just some of the surrounding space with the tiniest half moons. His cosmic touch on space is in my drawings even now.

Soon religion was pressed upon me to nullify whatever childish optimism I may have had left. Rank suppression at seven in the name of God the Father or any other of the heavenly host did not deter me from devising fantasies in secret. I heard the altar boys' whispered responses in strange Latin as the beautiful soprano of angels concealed behind the high altar.

In time, I grew curiously fond of the solemn high funeral mass which was so consummately rich in incense, music, chant, vestments, processionals and candlelight. Besides that, I got fifteen cents a corpse serving as an acolyte.

I also dwelled in serious fantasies of war—digging in with lead soldiers under the Japanese yews in my father's rock garden, and changing pencil sketches of World War devastation as it progressed, these depictions mutually drawn with an older friend, who, as an aerial gunner, was killed over Guam in the next real war.

Before I was ten, I had filled a corrugated paper carton with hundreds of pencil and pen-and-ink drawings after the "Horrors of War" picture cards of Gum, Incorporated, and sundry other war-time illustrations.

In parochial school, I was compelled to become a good student, a model child. The sisters diverted me from some of my war-torn tendencies and trained my hand in the peaceful uses of watercolor, but they did not permit much freedom for thought about what was to be drawn and washed.

My class work—dutifully done drawings and watercolors on prescribed themes—was preserved in folders by the nuns as good example for the students of following years until, when in 8A, I defied one of the good sisters by putting two handles on a vase of flowers instead of one as she demanded. I remember that that black lady called me a heretic or at least a sinner, but one look at my plump innocence checked her incipient anger and restored her to modest nunliness.

At fourteen, my father committed my brother and me to a junior seminary in Brooklyn so that we might doubly fulfill his own lost vocation. No one had asked me if I wanted to go there, but that hardly mattered, since I had not been permitted to contemplate much else since birth.

I continued drawing privately in class, in the margins of my textbooks. Now there were battered profiles of boxers with broken noses and Dido's pyre on a wall in Carthage, its passionate smoke piercing "pious" Aeneas' faithless heart outbound in the harbor below.

Young Father Fogarty, my Second Year Latin professor, was unimpressed with my talent, especially as it continually evolved in his class against his daily lesson plan. He often censured, even ridiculed, me. I

untitled, 1963–66 (detail)
Fluorescent light fixtures with cool-white
and warm-white lamps
Edition 1 of 3
5 ft. fixtures; 304.8 x 27.9 x 19.1 cm
(120 x 11 x 7½ inches)
Solomon R. Guggenheim Museum, New York,
Panza Collection 91.3699

untitled, 1966
Fluorescent light fixtures with cool-white lamps
Edition 1 of 3
6 and 8 ft. fixtures; 20.3 x 243.8 x 133.4 cm
(8 x 96 x 52½ inches)
Solomon R. Guggenheim Museum, New York,
Panza Collection 91.3702

acquired a certain personal power with him though. When he chastened me, he blushed redder than I did.

My grades worsened so badly by my senior year that I had to flee the seminary for the terrible profanity of life outside its Gothic walls which, in large measure, I had never experienced. At eighteen, I turned toward art.

I read art, looked for it, and listened about it. In an anti-aircraft battalion library hut in Osan-ni, Korea, I found only Jacques Maritain's "Art and Poetry." It was rough going. After buying a pair of Georges Rouault's prints from his "Miserer et Guerre," I wrote an American fan letter to the aging master. He answered touchingly with a poem. On a Saturday afternoon in the office at the Hansa Gallery, where a generation of new New York art was being born, Dick Bellamy, Ivan Karp, George Segal and Allan Kaprow carried on a "bull session" before me.

Since leaving high school, I had done little drawing and no painting until, in 1955, while loitering in Korea with an army of occupation, I became so restless in mind that I sought out another reluctant soldier, an Army private from Special Services, who had studied painting in Oberlin College and would not bathe for four days in a row as some sort of more personal esthetic assertion. I assisted him in setting up a regular class session in figure drawing. Within a few weeks, our program was suspended by an Army major whose obscene eyes saw the probability of a possibility of an unmanly, immoral disclosure in the posing of fellow G.I.'s stripped to the waist while leaning on brooms.

Fortunately, I stopped formal instruction in art after four inconclusive sessions at the Hans Hofmann School in 1956. Following that discouraging experience, my drawing had the considered criticism of a new "American" painter, Albert Urban, a gentle unreconstructed pariah, who, as a young man, had had his work acclaimed in Hitler's museum for "degenerate" art. I never worked in his studio, which he kept as his barred sanctuary daily from nine to five, but, on several evenings, weeks apart, we sat for hours with his wife, Reva, in their spacious West Tenth Street apartment, pouring over my misdirected papers.

After scanning my first batch of divers expression, Albert sighed, settled back in his easy chair, lighted his pipe and, for a while, distractedly puffed smoke through his wiry black mustache. When he finally spoke, he hesitantly suggested that I might better become a scholar—a religious art historian at that.

I was secretly shocked and grieved by Albert's lack of recognition. In the months that followed, I fervently poured out more hundreds of bad

drawings and a few horrid aspirations in oil on canvas paper and canvas board which I supposed must be what paintings were like. Albert, with immense tolerance, kept looking and talking but he could not be encouraging.

On a sudden, dear Albert suffered a heart attack and died on his living room floor. I was entirely on my own again. This was 1958.

During this time, I took survey courses in art history and Ralph Mayer's "Tools and Materials" program for two semesters at Columbia University.

These classes with Mr. Mayer put me in touch with a variety of antique artistic modes of "permanent painting" which no one will ever use again. In the second semester, I glazed a still-life too intensely and got a thin "B" for the effort.

In February 1959, with my personal affairs in a tangle, I burst out of Columbia University into a belated full-time affair with art. At first, I was on my own with everybody else's work—Guston's, Motherwell's, Kline's, Gorky's, Pollock's, Rothko's, Jasper Johns' and "What have you seen in the new Art News?"

My friend, Ward Jackson, used to send me inspirational postcards bearing reproductions of ten year old Motherwell paintings which looked strikingly like my last week's work, but nevertheless, I persisted because, by then, I knew no other way to live. My work was always on my mind.

For a year or more, I celebrated just about anything: crude Cézanne's self-portrait mask ennobled in a whirl of charcoal; drab tenements on the waterfront profiled in oil—sienna, umber, ochre, black and white; freight trains through the rain, rendered by smears of fingered ink; misspent ejaculations of watercolor and ink on their own; the "Song of Songs" in my own script, embraced by tender washes that spoke of giving breasts in the field in morning light; a Luis Lozano Olive Oil tin found flattened in the gutter disclosed as itself fastened to a golden box marked, "mira, mira."

By now, I had established my first studio, a sunny railroad flat on Washington Street in the midst of the old wholesale meat market on Manhattan's West Side below Fourteenth Street, and near the Hudson River waterfront. (I have always lived by large bodies of water. I love their breadth in constant flux.)

This place quickly grew chock full of curiosities—a dance of strung out objects—arranged like a strange, dirty, cumulative composition but with a random look. All the materials displayed there were found in my wanderings along the waterfront.

When Dick Bellamy first visited me there, he paced from room to room delightedly for some time, and then announced that he wished he could transport the entire apartment to his new Green Gallery. It never occurred to me that the way I wanted to live could become a saleable work of art.

By 1961, I was tired of my three year old romance with art as tragic practice. I found that all my small constructions, with the exception of "mira, mira," were memorial plaques and that the numerous pages and folding books of watercolor and poetry which I had made were drowned in funereal black ink.

My four room flat had shrunk to a closet around my mind. There were too many things of old emotion there. I had to abandon it. My new wife, Sonja, and I pooled our earning so that we could rent a large loft away in Williamsburg, Brooklyn, where I could start again to change those small celebrations into something grander—a more intelligent and personal work.

While walking the floor as a guard in the American Museum of Natural History, I crammed my uniform pockets with notes for an electric light art. "Flavin, we don't pay you to be an artist," warned the custodian in charge. I agreed, and quit him.

These notes began to find structural form in the fall. My wife and I were elated at seeing light and paint together on the wall before us. Then, for the next three years, I was off at work on a series of electric light "icons."[1]

Some previously sympathetic friends were alienated by such a simple deployment of electric light against painted square-faced construction. "You have lost your little magic," I was warned. Yes, for something grander—a difficult work, blunt in bright repose.

Somewhere in my mind, at this time, were quietly rebellious thoughts about proposing a plain physical painting of firm plasticity in opposition to the loose, vacant and overwrought tactile fantasies spread over yards of cotton duck (my friend, Victor Caglioti, has labelled these paintings, "dreaming on a brush") that overwhelmed and stifled the invention of their practitioner-victim—a declining generation of artists whom I saw out there before me in prosperous commercial galleries. (I do not mean to be misleading. Plastic polemics did not persuade me to initiate work. Most of the time, I simply thought about what I was going to build next.)

Work that was new to my attention such as the homely objective paint play about objects of Jasper Johns, the easy separative brushed on vertical bar play in grand scale by Barnett Newman or the dry multi-striped consecutive bare primed canvas-pencil-paint frontal expanse play from Frank Stella did not hold an appropriate clue for me about this beginning. I had to start from that blank, almost featureless, square face which could become my standard yet variable emblem—the "icon."

In the spring of 1963, I felt sufficiently founded in my new work to discontinue it. I took up a recent diagram and declared "the diagonal of personal ecstasy" ("the diagonal of May 25, 1963"), a common eight foot strip of fluorescent light in any commercially available color. At first, I chose gold.

The radiant tube and the shadow cast by its pan seemed ironic enough to hold on alone. There was no need to compose this lamp in

untitled, 1966 (detail)
Fluorescent light fixtures with cool-white lamps
Edition 1 of 3
6 and 8 ft. fixtures; dimensions vary with installation
Solomon R. Guggenheim Museum, New York, Panza Collection 91.3703

place; it implanted itself directly, dynamically, dramatically in my work-room wall—a buoyant and relentless gaseous image which, through brilliance, betrayed its physical presence into approximate invisibility.

(I put the lamp band in position forty-five degrees above the horizontal because that seemed to be a suitable situation of dynamic equilibrium but any other placement could have been just as engaging.)

It occurred to me then to compare the new "diagonal" with Constantin Brancusi's past masterpiece, "the endless column." That "column" was a regular formal consequence of seemingly numerous similar wood wedge-cut segments surmounting one another—a hand hewn sculpture (at its inception). "The diagonal" in its overt formal simplicity was only a dimensional or distended luminous line in a standard industrial device.

Both structures had a uniform elementary visual nature. But they were intended to excel their obvious visible limitations of length and their apparent lack of expressiveness—visually—spiritually. "The endless column" had evident overtones returning to distant symbols. It was like some archaic mythologic totem which had continued to grow, surging skyward. "The diagonal," on the other hand, in the possible extent of its dissemination as a common strip of light or a shimmering slice across anybody's wall, had the potential for becoming a modern technological fetish; but, who could be sure how it would be understood?

Immanuel Kant explained in his "Critique of Judgment" that ". . . the Sublime is to be found in a formless object, so far as in it, or by occasion of it, boundlessness is represented." He seemed to speak to both these structures.[2]

In time, I came to these conclusions about what I had found in fluorescent light, and about what might be done with it plastically:

Now the entire interior spatial container and its parts—wall, floor and ceiling, could support this strip of light but would not restrict its act of light except to enfold it. Regard the light and you are fascinated—inhibited from grasping its limits at each end. While the tube itself has an actual length of eight feet, its shadow, cast by the supporting pan, has none but an illusion dissolving at its ends. This waning shadow cannot really be measured without resisting its visual effect and breaking the poetry.

untitled (to Ward Jackson, an old friend and colleague who, during the Fall of 1957 when I finally returned to New York from Washington and joined him to work together in this museum, kindly communicated), 1971
Fluorescent light fixtures with daylight, pink, yellow, green, and blue lamps
2 ft. and 8 ft. fixtures; dimensions vary with installation
Solomon R. Guggenheim Museum, New York,
Partial gift of the artist in honor of Ward Jackson
72.1985

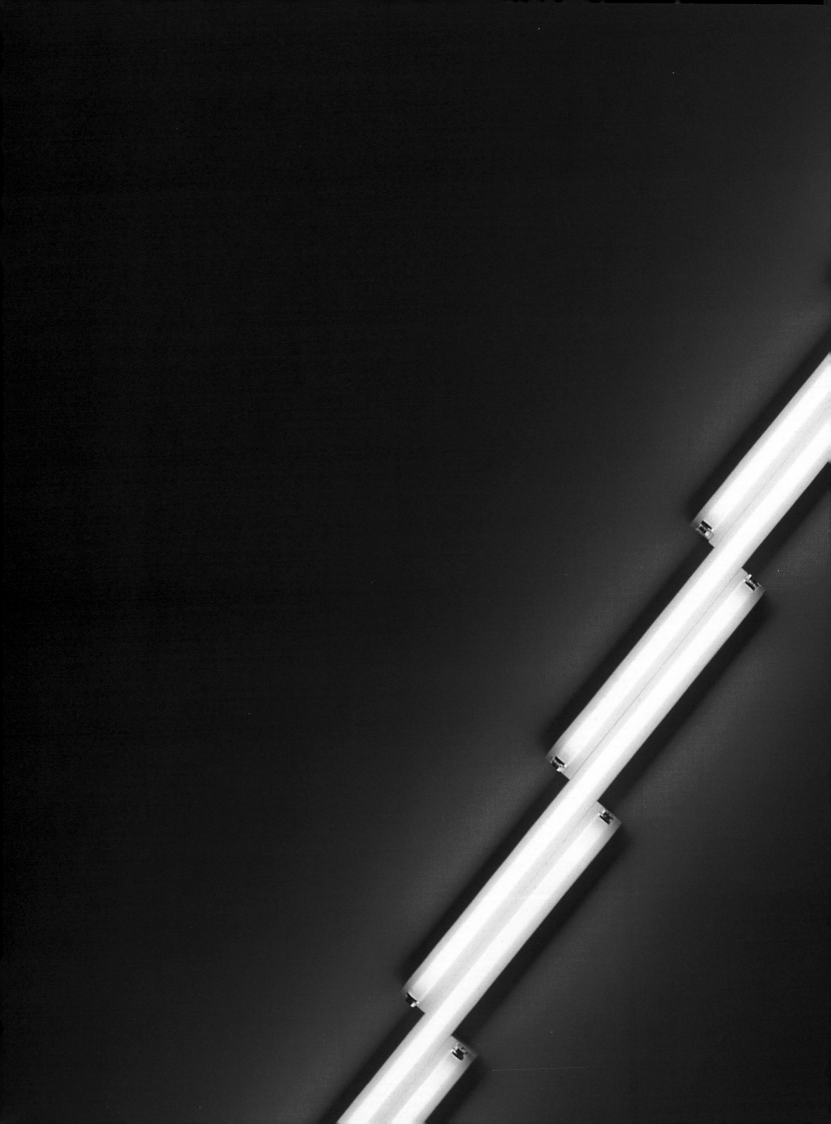

Realizing this, I knew that the actual space of a room could be broken down and played with by planting illusions of real light (electric light) at crucial junctures in the room's composition. For example, if you press an eight foot fluorescent lamp into the vertical climb of a corner, you can destroy that corner by glare and doubled shadow. A piece of wall can be visually disintegrated from the whole into a separate triangle by plunging a diagonal of light from edge to edge on the wall; that is, side to floor, for instance.

These conclusions from completed propositions (in the Kaymar Gallery during March 1964 and in the Green Gallery during November 1964 and December 1964) left me grounded at play on the structure that bounded a room but not yet in the volume of air space which is so much more extensive than the room's box.

Since December 1964, I have made tentative attempts at this (in the Institute of Contemporary Art from March 1965 through May 1965, and again at The Ohio State University during April 1965 and May 1965) through bringing the lamp as image back into balance with the other side of its duality as object by dropping it diagonally from the wall out onto the floor in Philadelphia; by extending it horizontally out of an entry arch into the room in Philadelphia and, in Columbus, by placing a pattern of lamps as a complement to the ascent and descent of a flight of stairs and then letting a sole, two-foot, cool, white fluorescent strip act as a horizontal visual bar across the staircase.

What has art been for me?

In the past, I have known it (basically) as a sequence of implicit decisions to combine traditions of painting and sculpture in architecture with acts of electric light defining space and, recently, as more progressive structural proposals about these vibrant instruments which have severalized past recognitions and swelled them effluently into almost effortless yet insistent mental patterns which I may not neglect. I want to reckon with more lamps on occasion—at least for the time being.

1. I used the word "icon" as descriptive, not of a strictly religious object, but of one that is based on a hierarchical relationship of electric light over, under, against and with a square-faced structure full of paint light.
2. In November 1964, the Green Gallery, held by strategic lines of light, became a quiet cavern of muted glow.

(1965)

Last week in the Metropolitan, I saw a large icon from the school of Novgorod. I smiled when I recognized it. It had more than its painting. There was a physical feeling in the panel. Its recurring warp bore a history. This icon had that magical presiding presence which I have tried to realize in my own icons. But my icons differ from a Byzantine Christ held in majesty; they are dumb—anonymous and inglorious. They are as mute and indistinguished as the run of our architecture. My icons do not raise up the blessed saviour in elaborate cathedrals. They are constructed concentrations celebrating barren rooms. They bring a limited light.

(1962)

With *the nominal three* I will exult primary figures and their dimensions. Here will be the basic counting marks (primitive abstractions) restated long in the daylight glow of common fluorescent tubes. Such an elemental system becomes possible (ironic) from the context of my previous work.

(1963)

. . . On this sheet, I enclose a lovely tempering aphorism which has been with me for a few years. "Entia non multiplicanda praeter necessitatem." "Principles (entities) should not be multiplied unnecessarily." Of course it is "Ockham's Razor." If I were you, I would feature it. Briefly, my Columbia Viking Desk Encyclopedia recognizes William of Ockham thusly . . . "d.c. 1349, English scholastic philosopher, a Franciscan. Embroiled in a general quarrel with Pope John XXII, he was imprisoned in Avignon but fled to the protection of Emperor Louis IV and supported him by attacking the temporal power of the papacy. Rejecting the doctrines of Thomas Aquinas he argued that reality exists solely in individual things and universals are merely abstract signs. This view led him to exclude questions such as the existence of God from intellectual knowledge, referring them to faith alone."
"The nominal three" is my tribute to William . . .

(1966)

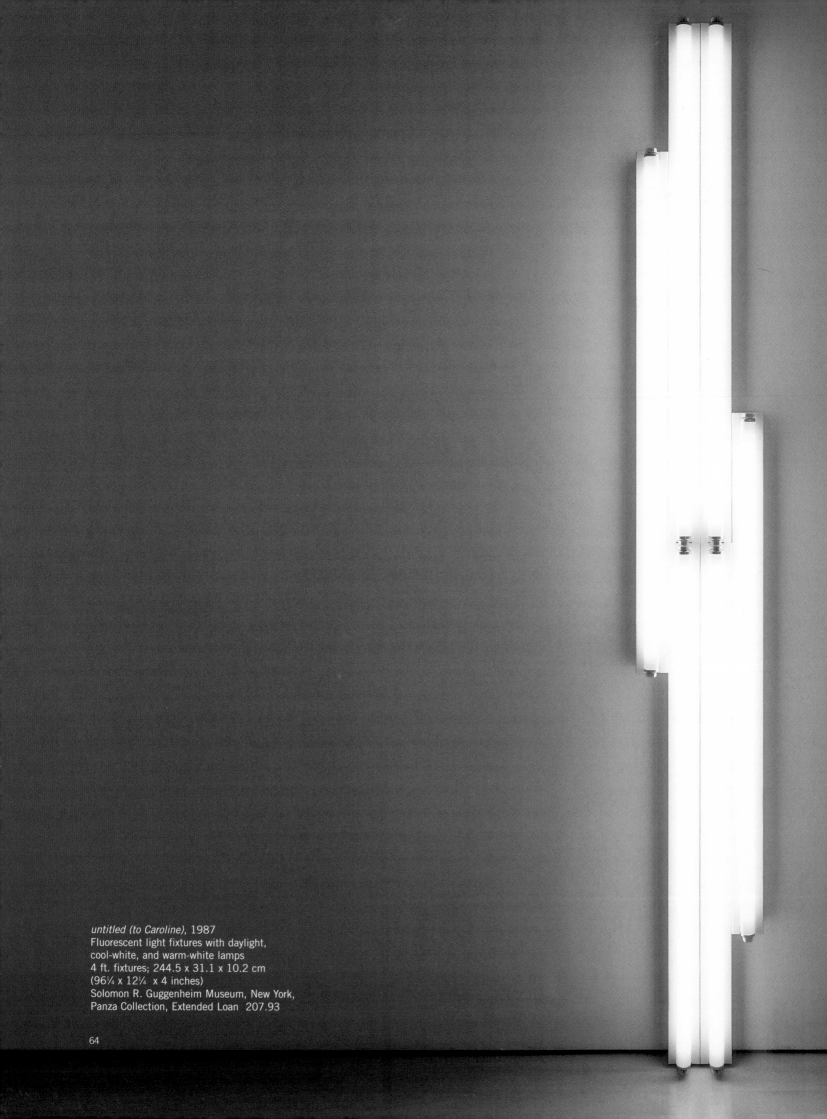

untitled (to Caroline), 1987
Fluorescent light fixtures with daylight,
cool-white, and warm-white lamps
4 ft. fixtures; 244.5 x 31.1 x 10.2 cm
(96¼ x 12¼ x 4 inches)
Solomon R. Guggenheim Museum, New York,
Panza Collection, Extended Loan 207.93

"orogeny . . . the process of mountain formation, esp. by folding of the earth's crust."
—*Merriam Webster's Seventh New Collegiate Dictionary*

"I have tried to make an architecture for a technological society," Mies said.

"I have wanted to keep everything reasonable and clear to have an architecture that anybody can do."
—Mies van der Rohe

(Since these remarks are drawn from a recent version of *Time* magazine, one can only hope that they are authentic.)

As in the recent past, the current art has set its trap for you, the young professional students, who are searching for it with presumed impatience; it seems to be easy to do.

In art schools of the 1950's, young people were encouraged often to wield a loaded brush against all surfaces and to weld something rusty to something rusty and so forth. Insouciance was out of order. The serious look of broad emotional gestures for complicated spaces was promoted. A certain passion could be expected to guarantee results—well, almost results.

Today, in an aftermath of celebration for simple statements from the paintings of Barnett Newman, Mark Rothko and Ellsworth Kelly, through so-called hard edge painting, so-called color field painting, "pop art," "op art," the shaped canvas to the sculpture of Robert Morris and Donald Judd, one-man show business can be more easily-joyously perpetrated than was generally suspected in the preceding decade. (It is no longer necessary for you to punish oak with hammer and chisel, to molest sheet steel with an acetylene torch or to drown plywood in slick epoxy paint—in short, to learn the trade of contemporary sculpture.)

The contents of any hardware store could supply enough exhibition material to satisfy the season's needs of the most prosperous commercial gallery. For instance, should you press ten yards of tightly woven aluminum wire screening against a wall with more or less strategically driven copper tacks, your design would surely suffice for a mural at Leo Castelli's. (With it, you might have advanced another "synthesis" based on the statements of his gallery artists—a kind of Larry Poons by Don Judd.) Or you may wish to try a minor sado-masochistic "happening" by joining your clients in running barefoot through mounds of upholstery nails and carpet tacks. (Do not worry about being arrested, sued, or being placed in the care of a psychiatrist; Allan Kaprow never has been. Don't forget the iodine and Band-Aid patches, though.) Or, you might want to flood your favorite gallery with a roving garden sprinkler while taking a cooling shower with a favored girl friend.

(These days, your performance would be well recognized in the "Scene" as kinetic dance event—especially if the water was cold and deep enough to submerge the baseboard electrical outlets.)

"Gasp!," as Roy Lichtenstein might say. Where have I left you—shocked by these simple yet stunning alternatives for success in sculpture or sculptural extensions this year. Possibly, but I hope not. I would want you to retort with questions about problems not for me but for you yourself, about what you are doing where you are.

Should you leave this room, this school and never return? Had you better not undertake studies in thermodynamics next week? What about sculpture as a categorical procedure; has its meaning become merely a matter for art history and of no concern to you?

Don Judd, who has one of the most deft intellects at work in New York, has claimed that painting on canvas is obsolete. Now could you make a similar determination about the sculpture which you are working on or plan to attempt? Parenthetically, my own proposal has become mainly an indoor routine of placing strips of fluorescent light. It has been labelled sculpture by people who should know better.

If you can depart from here today without seriously interrogating yourself, you are either deaf, inattentive, foolish, insufficient, uncertain or bored. (If the last condition obtains, you may have genius potential.)

(1966)

untitled (to Eugenia), 1987
Fluorescent light fixtures with cool-white,
daylight, and warm-white lamps
Edition 3 of 5
4 ft. fixtures; 244.2 x 38.7 x 10.2 cm
(96¹⁄₈ x 15¼ x 4 inches)
Panza Collection, Gift to Fondo per l'Ambiente
Italiano, 1996, on permanent loan to the
Solomon R. Guggenheim Foundation, New York,
201.93

Thus far, I have made a considered attempt to poise silent electric light in crucial concert point to point, line by line and otherwise in the box that is a room. This dramatic decoration has been founded in the young tradition of a plastic revolution which gripped Russian art only forty years ago. My joy is to try to build from that "incomplete" experience as I see fit.

(1965)

One's proposal challenges what one thinks art might become (even its existence). Asking out about whether or not art exists has developed into an intellectual pose after Duchamp's lead. It is gilding the ego and not worth much to one's colleagues.

(1966)

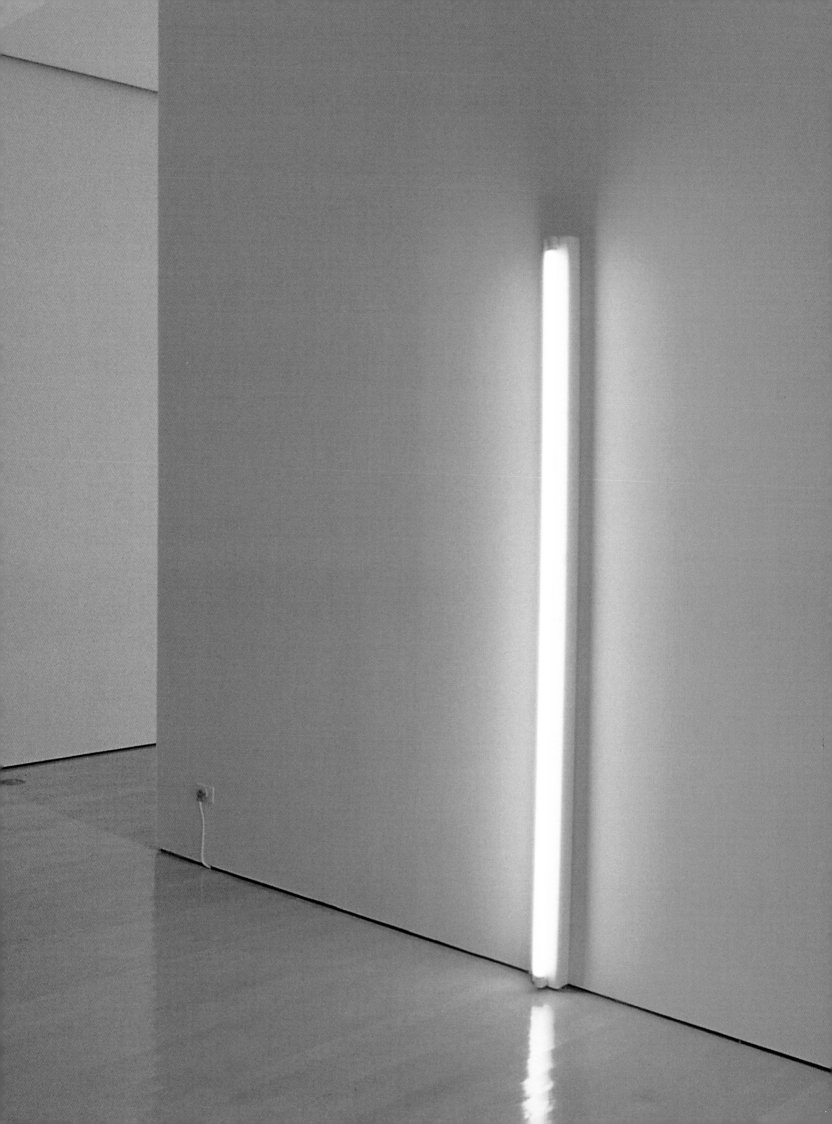

Contrary to your opening remarks on first use six years ago, I found electric light to have a strong visual impact. That was the easiest of recognitions . . .

Your statement, "The major catalyst was Pop," is incorrect as far as my effort is concerned. In 1957 (correction), I deliberately entered tradition of abstract art through certain paintings (omission correction). . . . I have thought from there. Nevertheless, I try never to acknowledge "isms" on art because of their usual unanimous inaccuracy.

My constructions of 1961 through 1963 concerned problems with electric light only. . . .

By the way, at the start (of my use of electric light), I knew nothing of the Moholy-Nagy sculpture or, for that matter, all of the output of the European solo systems and groupings like *Zero* which were introduced to New York relatively recently or not at all. Again, remember that Mr. Green's dilemma (at finding artists whose work could be included in his *Current Art* exhibition of spring, 1965) was not from ignorance of what was being attempted but from lack of available results of engaging quality.

I recall that the (New York) Museum of Modern Art's "Lumia" installation behind heavy curtains was considered merely a curiosity by most artists and known as a rendezvous for boys and girls and boys and boys and so forth. It did not entertain me. It looked like a softly shifting abstract painting that never could resolve effectively—something similar to Paul Jenkins's canvases in motion.

The equipment which I deploy seems to me to be neither ugly nor handsome.

"There is no room for mysticism in the Pepsi denigration," is a quote of mine for a survey (of artists) during the last year. I mean that remark emphatically. My fluorescent tubes never "burn out" desiring a god.

I prefer the term "proposal" and endeavor to use it accurately. I know no "work" as my art.

For a few years, I have deployed a system of diagramming designs for fluorescent light in situations. Of course, I was not immediately aware of that convenience and its inherently fascinating changes. I assume that it "developed" without my explicit or regular recognition. Also, a number of diagrams had to accumulate before a kind of reciprocity could obtain. Now, the system does not proceed; it is simply applied. Incidentally, I have discovered that no diagram is inappropriate for my file. None need be prevented, suspended or discarded for lack of quality. Each one merely awaits coordination again and again. Sometimes, adjustments or new variants are implied. Then, and only then, do I think to move my pencil once more. I am delighted by this understanding.

Yes, fluorescent light fixtures are unwieldy to place, particularly away from a flat surface. I am conscious about being exceedingly careful with that part. I aim constantly for clarity and distinction first in the pattern of the tubes and then with that of the supporting pans. But, with or without color, I never neglect the design.

(1967)

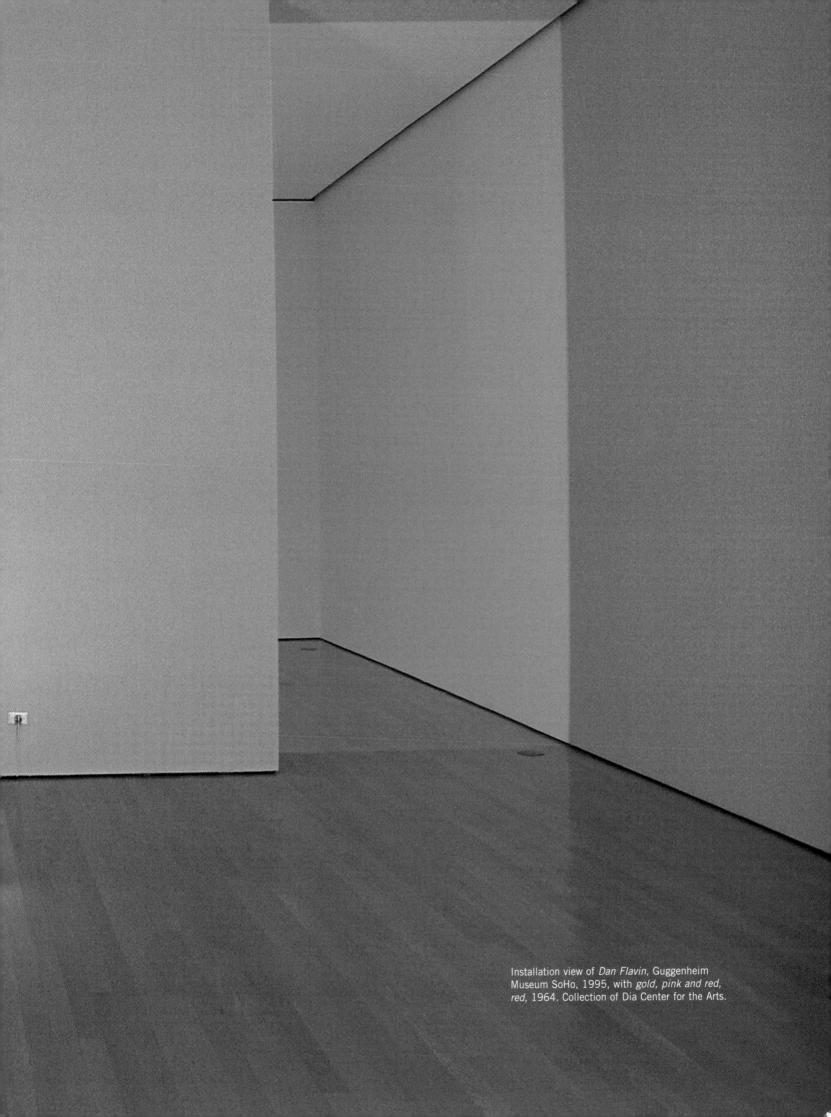

Installation view of *Dan Flavin*, Guggenheim
Museum SoHo, 1995, with *gold, pink and red,
red*, 1964. Collection of Dia Center for the Arts.

As I have said for several years, I believe that art is shedding its vaunted mystery for a common sense of keenly realized decoration. Symbolizing is dwindling—becoming slight. We are pressing downward toward no art—a mutual sense of psychologically indifferent decoration—a neutral pleasure of seeing known to everyone.

(1966)

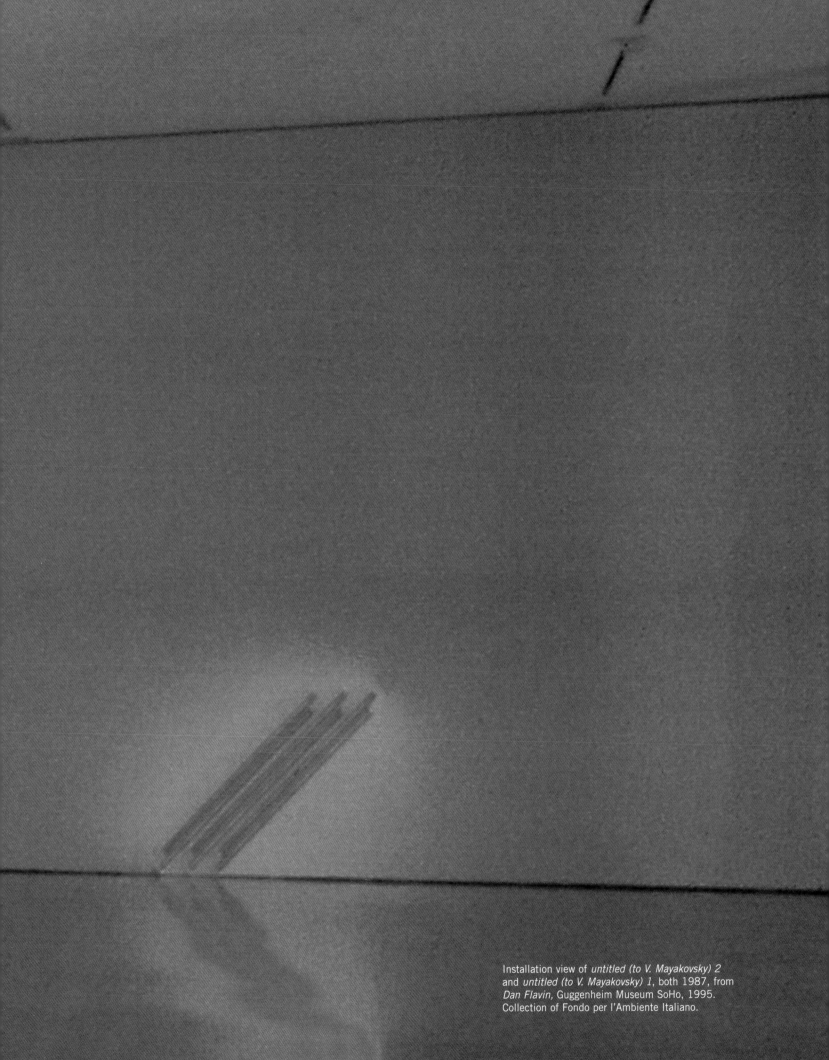

Installation view of *untitled (to V. Mayakovsky) 2*
and *untitled (to V. Mayakovsky) 1*, both 1987, from
Dan Flavin, Guggenheim Museum SoHo, 1995.
Collection of Fondo per l'Ambiente Italiano.

I know now that I can reiterate any part of my fluorescent light system as adequate. Elements of parts of that system simply alter in situation installation. They lack the look of a history. I sense no stylistic or structural development of any significance within my proposal—only shifts in partitive emphasis—modifying and addable without intrinsic change.

All my diagrams, even the oldest, seem applicable again and continually. It is as though my system synonymizes its past, present and future states without incurring a loss of relevance. It is curious to feel self-denied of a progressing development, if only for a few years.

(1966)

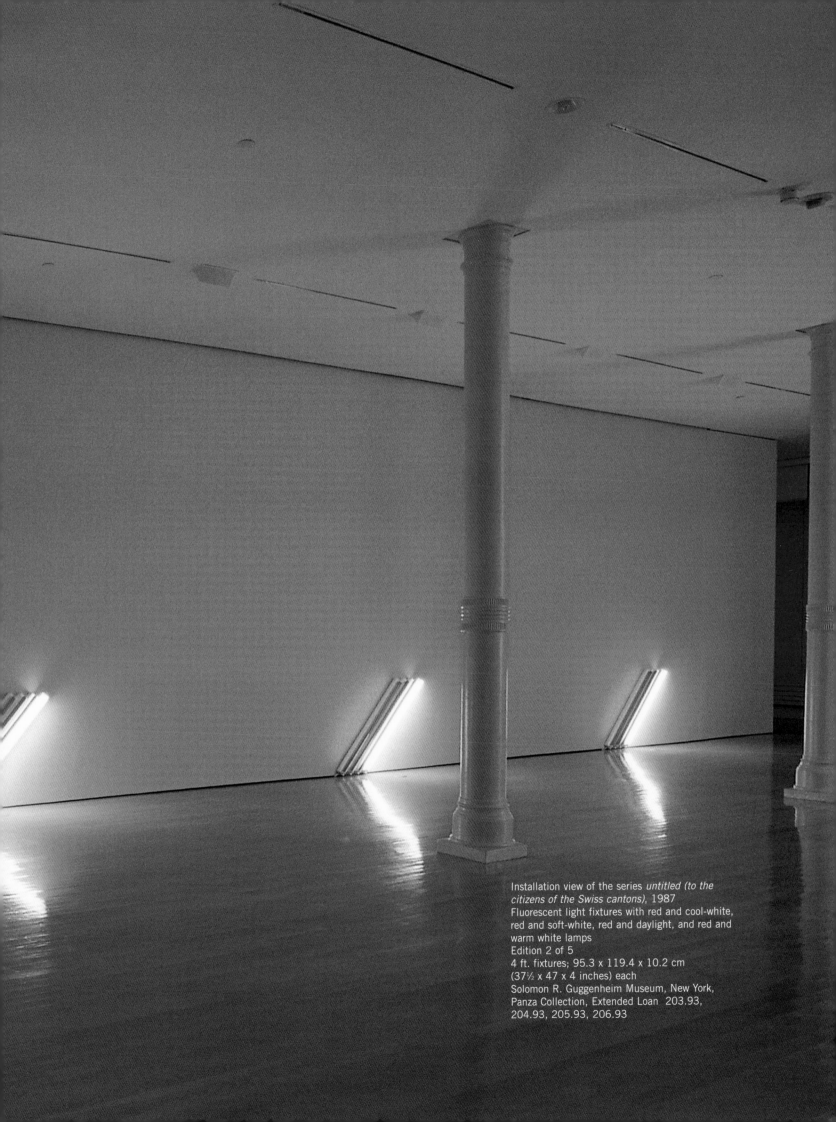

Installation view of the series *untitled (to the
citizens of the Swiss cantons)*, 1987
Fluorescent light fixtures with red and cool-white,
red and soft-white, red and daylight, and red and
warm white lamps
Edition 2 of 5
4 ft. fixtures; 95.3 x 119.4 x 10.2 cm
(37½ x 47 x 4 inches) each
Solomon R. Guggenheim Museum, New York,
Panza Collection, Extended Loan 203.93,
204.93, 205.93, 206.93

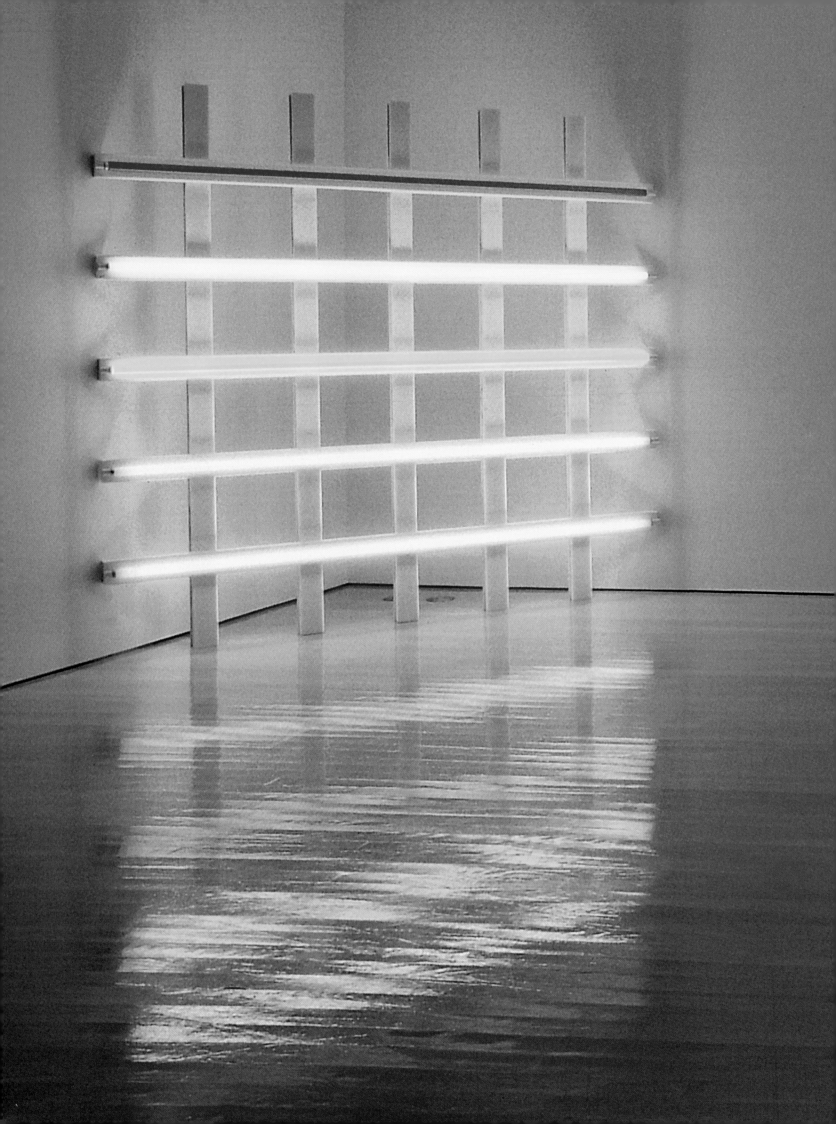

Electric light is just another instrument. I have no desire to contrive fantasies mediumistically or sociologically over it or beyond it. Future art and the lack of that would surely reduce such squandered speculations to silly trivia anyhow. . . .

(1966)

untitled (in honor of Leo at the 30th anniversary of his gallery), 1987
Fluorescent light fixtures with red, pink, yellow, blue, and green lamps
Edition 1 of 3
8 ft. fixtures; 243.8 x 243.8 x 23.5 cm
(96 x 96 x 9¾ inches)
Panza Collection, Gift to Fondo per l'Ambiente Italiano, 1996, on permanent loan to the Solomon R. Guggenheim Foundation, New York, 195.93

In the beginning, and for some time thereafter, I, too, was taken with easy, almost exclusive recognitions of fluorescent light as image. Now I know that the physical fluorescent light tube has never dissolved or disappeared by entering the physical field of its own light as you have stated. At first sight, it appeared to do that, especially when massed tightly with reciprocal glass reflections resulting as within "the nominal three" but then, with a harder look, one saw that each tube maintained steady and distinct contours despite its internal act of ultraviolet light which caused the inner fluorescent coating of its glass container to emit the visible light. The physical fact of the tube as object in place prevailed whether switched on or off. (In spite of my emphasis here on the actuality of fluorescent light, I still feel that the composite term "image-object" best describes my use of the medium.)

What I have written further explains (it even alters) notions contained in the last paragraphs of ". . . in daylight or cool white" and denies current interest on my part in what appears to be metaphysical thought about light and related visual activity.

(1966)

Installation view of *Dan Flavin*, Guggenheim Museum SoHo, 1995, with *untitled (to Eugenia)*, 1987.

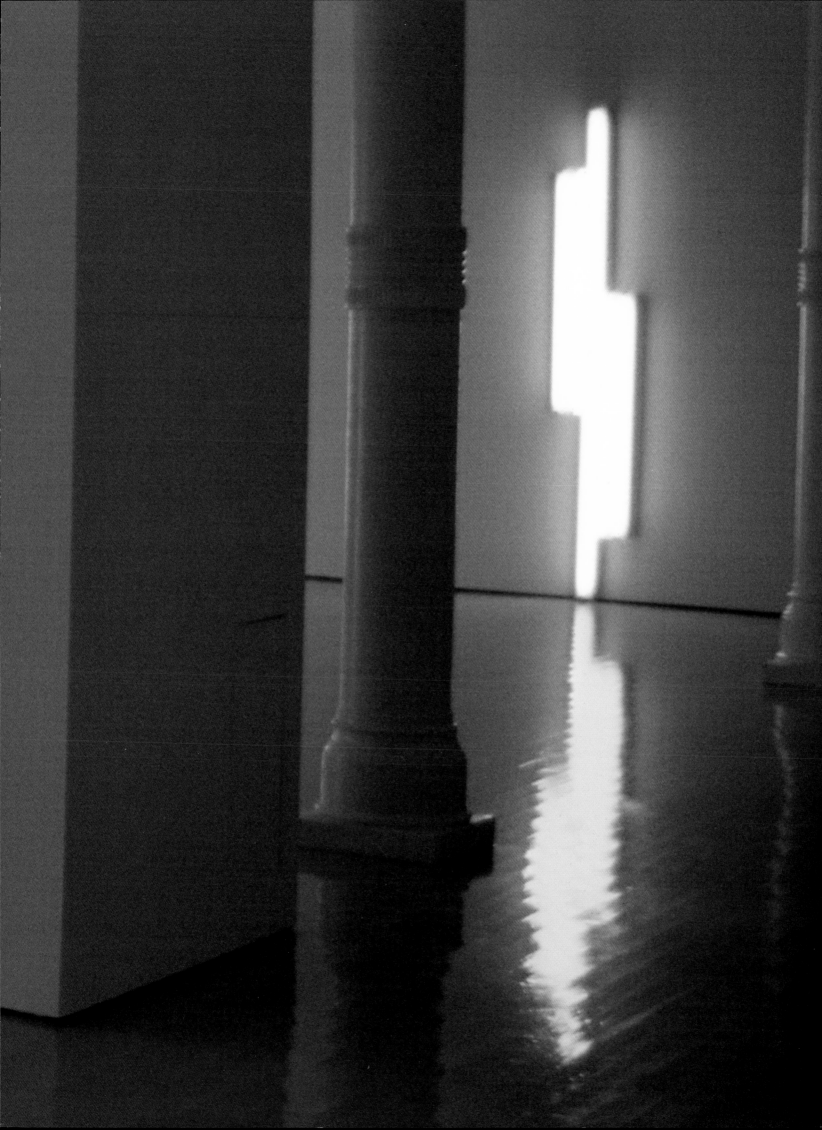

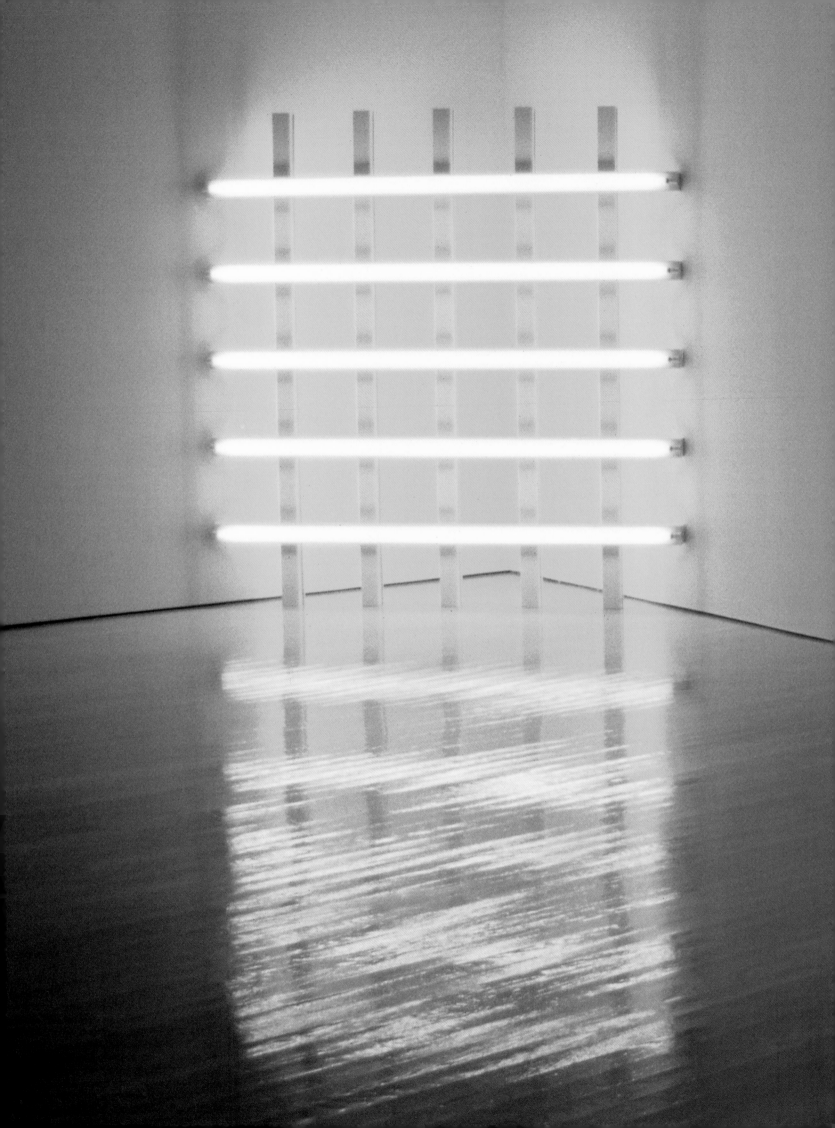

I don't want to impose separate sculptural ego dumps as public works. I don't want to rival architecture and public spaces insistently grandiosely. I have in the past and do intend to continue so now to adapt my art carefully and complementarily publicly. But that's easy for me. I admire the area of interest. (Incidentally, I lost what I sensed was 'the right time' for my own potential education in architecture to a four-year tour of duty, mainly with the Air Weather Service within United Nations military forces during the past Korean War.) What I have found to be difficult, even risky, in public service, and what may continue to be, is maintaining an ironic differentiation between what I must and might have for myself, and possibly for others, as art apart and the ordinary mechanical design solutions of the job to be done—say, useless, intensely thought artifice of art, particularly patterned and lighted once more, and discreetly balanced with an arrangement of sufficient numbers of lamps for useful illumination. But apparently art and design must be processed within each other at once. And finally, from the constant fusion, I have to be able to recognize art because I prefer it.

Otherwise, broad concern and support for artists to perform in public is still principally wanting in this country, but therein is another essay which I cannot perpetrate here and now.

(1972)

Installation view of *untitled*, 1987, from
Dan Flavin, Guggenheim Museum SoHo, 1995.
Panza Collection, Gift to Fondo per l'Ambiente
Italiano.

Kirk Varnedoe, in his talk of "Pollock's Legacy," uniformly referred to painting as "pictures." But there are differences among artists by pictorial degree and, by now, then some. Mr. de Kooning, for instance, definitely limited himself by paint attitude toward figuration, scale sense and shape of canvas for depiction. Mr. Pollock did not. He strained openly against those restrictions with some noteworthy success, although it must be noted that Mr. Pollock did figure illusionistic space. His most notable failing was to allow his potentially broad acts of paint-ings to be packaged, small to large, for gallery and museum commerce on canvas stretcher bars.

By now, America has "paint and paint-like things," limited as they, too, maybe. Colored atmosphere has been the logical prospect beyond painting. It has rarely been attempted or reached.

Don Judd and I, among others, chose to forgo painting and its beyond, each in our own ways. My physical facts of fluorescent lighting equip-ment permit colored light with reflective atmospheric reach. Over twenty years ago, I appealed to General Electric engineers to show me a way outward to artificial light without a vacuum enclosure. They would not perhaps, could not, despite some faint indications of research in the matter.

O.K., at this point, it must be clear that my interpretation of Mr. Pollock's painting, however "handmade," was positive learning not nega-tive reaction.

(1991)

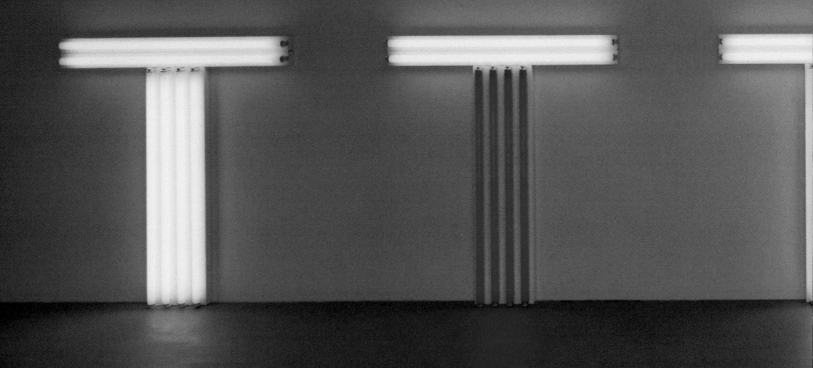

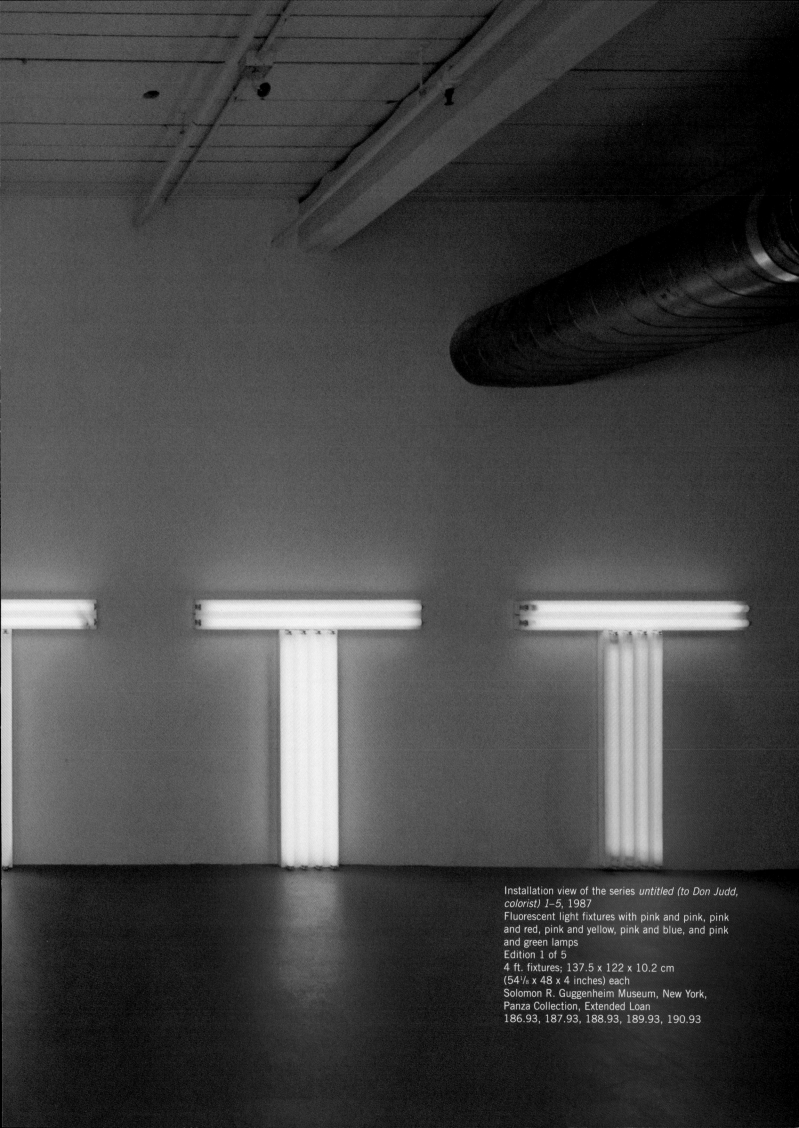

Installation view of the series *untitled (to Don Judd, colorist) 1–5*, 1987
Fluorescent light fixtures with pink and pink, pink and red, pink and yellow, pink and blue, and pink and green lamps
Edition 1 of 5
4 ft. fixtures; 137.5 x 122 x 10.2 cm
(54$^1/_8$ x 48 x 4 inches) each
Solomon R. Guggenheim Museum, New York, Panza Collection, Extended Loan
186.93, 187.93, 188.93, 189.93, 190.93

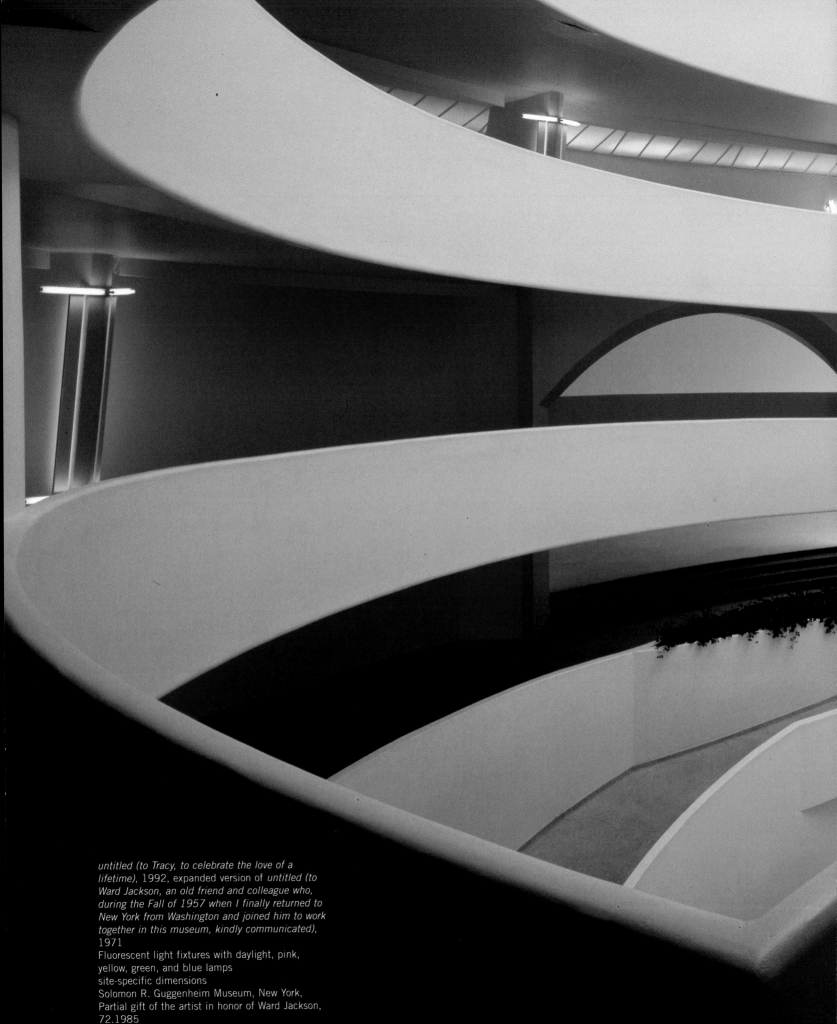

untitled (to Tracy, to celebrate the love of a lifetime), 1992, expanded version of *untitled (to Ward Jackson, an old friend and colleague who, during the Fall of 1957 when I finally returned to New York from Washington and joined him to work together in this museum, kindly communicated)*, 1971
Fluorescent light fixtures with daylight, pink, yellow, green, and blue lamps
site-specific dimensions
Solomon R. Guggenheim Museum, New York, Partial gift of the artist in honor of Ward Jackson, 72.1985

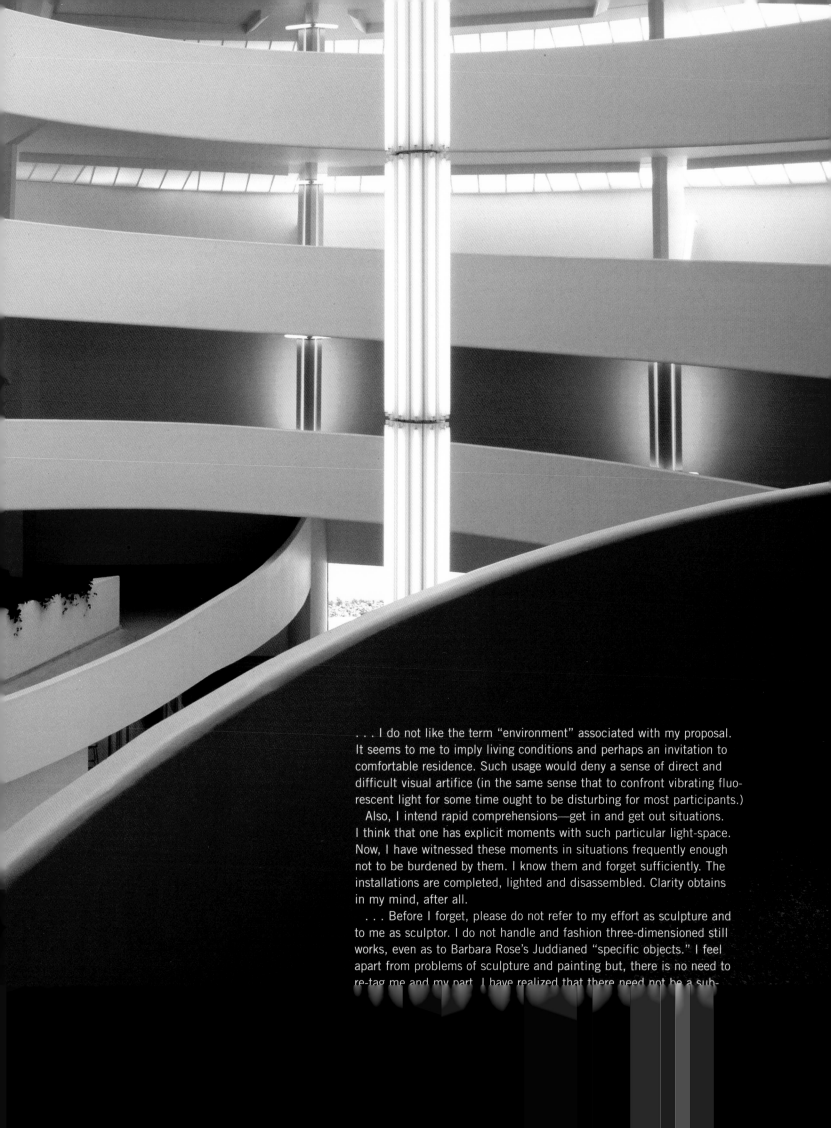

. . . I do not like the term "environment" associated with my proposal. It seems to me to imply living conditions and perhaps an invitation to comfortable residence. Such usage would deny a sense of direct and difficult visual artifice (in the same sense that to confront vibrating fluorescent light for some time ought to be disturbing for most participants.)

Also, I intend rapid comprehensions—get in and get out situations. I think that one has explicit moments with such particular light-space. Now, I have witnessed these moments in situations frequently enough not to be burdened by them. I know them and forget sufficiently. The installations are completed, lighted and disassembled. Clarity obtains in my mind, after all.

. . . Before I forget, please do not refer to my effort as sculpture and to me as sculptor. I do not handle and fashion three-dimensioned still works, even as to Barbara Rose's Juddianed "specific objects." I feel apart from problems of sculpture and painting but, there is no need to re-tag me and my part. I have realized that there need not be a sub-

to quote... or, to be safe, to paraphrase, Barney Newman,
"Aesthetics is to art as ornithology is for the birds."

where I began to think art significantly in 1957 . . . (for Sabine)

I fortunately missed variously prejudiced professional art school training.
I haltingly contrived my own artistic "education."
 I really made a noteworthy New York start between the paintings of
Bill de Kooning and those of Jackson Pollock. But I was unable, as they
were, to believe in painting as a sufficient, practical end in itself. I had
to push to put painting to use—first, all around manuscript pages then,
spread out at length across the folds of Japanese notebooks.
 You see, I learned eventually to ignore the grisly pictoral distortions
of women of Mr. de Kooning for the wildly intense, far better humored
drip, dribble, splash, dash painted systematics of Mr. Pollock at his
apparently self-assured uttermost. I sensed that they pretended toward
infinity—to painting anywhere—ultimately nohow nowhere.
 Another maturing source of interest became Marcel Duchamp's
"objectified" ready-mades. As ever, I had to develop a simple, straight-
forward, constructive, mediumistic approach away from his seeming
offputting art political positionings. In 1961, I began to discover an
abusive artifice for the phenomenal facts of artificial light.
 By now, I have become enthralled with light somewhere anyhow.

(1989)

situational light and, well beyond it . . . (for Sabine)

I prefer to refer to my use of artificial light as situational. The lamp lighting should be recognized and used simply, straightforwardly, speedily or, not. This is a contemporary, a sensible, artistic sense. No time for contemplation, psychology, symbolism, or mystery.

And what I propose is not at all environmental. It avoids inhabitability. This proposal is a temporal, factual, mediumistic artifice for existence— no more, no less. I was supposed to install a technically experimental program for the World's Fair, Osaka '70. The General Electric Company, in suburban Cleveland, Ohio, was to be the sustaining research source. But beyond the welcome of a friendly, young personal relations engineer, Terry McGowan, little to no information was revealed. I sensed suspiciously received, as though I was an alien rival company spy.

My back-up project, combining two standard stock General Electric systems, was dimming—strobing filtered ultra-violet fluorescent light. My preferred one was to provide artificial light which did not require electrification in a limited vacuum. I was after the latitude, the freedom, of all envelopment. Although some sorts of research had been conducted, they had failed apparently. Nevertheless, I was not to be informed.

Life in light continues.

untitled (to Tracy, to celebrate the love of a lifetime), 1992, expanded version of *untitled (to Ward Jackson, an old friend and colleague who, during the Fall of 1957 when I finally returned to New York from Washington and joined him to work together in this museum, kindly communicated)*, 1971

(1989)

. . . the lamps will go out (as they should, no doubt). Somehow I
believe that the changing standard lighting system should support my
idea within it. I will try to maintain myself this way. It may work out.
The medium bears the artist. . . .

(1966)

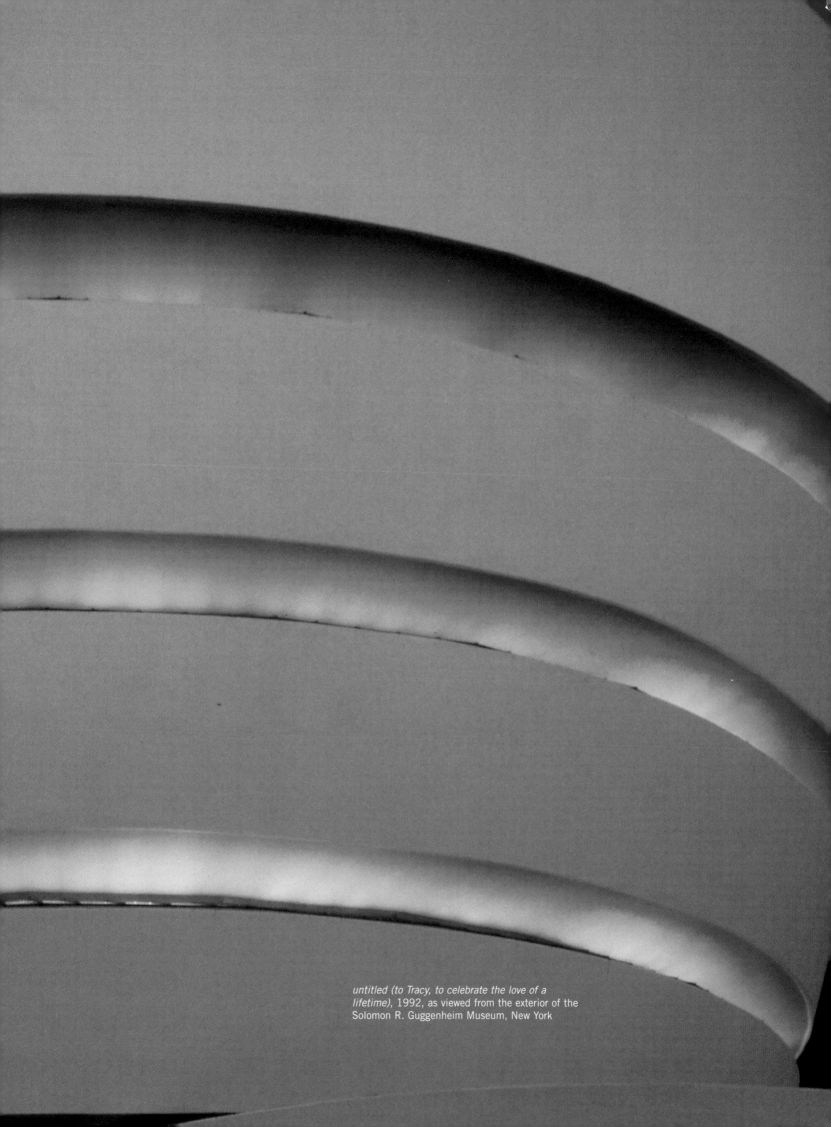

untitled (to Tracy, to celebrate the love of a lifetime), 1992, as viewed from the exterior of the Solomon R. Guggenheim Museum, New York

Sources for Writings

Page 47: *Dan Flavin: three installations in fluorescent light/Drei Installationen in fluoreszierendem Licht* (Exh. cat., Cologne: Wallraf-Richartz-Museums and Kunsthalle Köln, 1973), p. 82.

Page 48: Reproduced as figure 46 in *Dan Flavin: fluorescent light etc.* (Exh. cat., Ottawa: National Gallery of Canada for the Queen's Printer 1969), p. 119.

Page 50–61: This text is the first half of a lecture presented at the Brooklyn Museum Art School on December 18, 1964, and again, in revised form, in the Ohio State University Law School Auditorium on April 26, 1965. It was augmented for publication during the last week of August, 1965 and the first weeks of September, 1965. From " '. . . in daylight or cool white.' an autobiographical sketch." *Artforum* (Los Angeles) 4, no. 4 (December 1965), pp. 21–24.

Page 62: "Record" book entry dated August 9, 1962, in *Dan Flavin: three installations in fluorescent light/Drei Installationen in fluoreszierendem Licht*, p. 83.

Page 63: "Record" book entry dated August 8, 1963, in ibid., p. 83.

Page 63: Letter of November 1, 1966 to artist–art historian, Mel Bochner, in ibid., pp. 83–84.

Page 65–66: This speech was delivered to the senior and graduate students in sculpture at the Rhode Island School of Design, Providence, R.I., March 9, 1966. "Flavin Speech," *Blockprint* (Providence, R.I.) 15, no. 18 (March 21, 1966), unpaginated.

Page 68: Excerpt from an untitled statement by Dan Flavin in "The Artists Say," *Art Voices* (New York) 4, no. 3 (summer 1965), p. 72.

Page 68: "some remarks . . . excerpts from a spleenish journal," *Artforum* (Los Angeles) 4, no. 4 (December 1966), pp. 28–29.

Page 70: Letter of April 27, 1967, to Miss Elizabeth C. Baker, Managing Editor of *Art News*, in "some other comments . . . more pages from a spleenish journal," *Artforum* (Los Angeles) 6, no. 4 (December 1967), p. 21.

Page 72: "some remarks . . . excerpts from a spleenish journal," p. 27.

Page 74: Ibid.

Page 77: Ibid.

Page 78: Ibid.

Page 81: Artist's addendum to James Wood, "Notes on an exposition of cornered installations in fluorescent light by Dan Flavin set to celebrate ten years of the Albright-Knox Art Gallery," *Studio International* (London) 184, no. 950 (December 1972), p. 232.

Page 82: Excerpt from letter to Helen Harrison, July 30, 1991. Copy in Solomon R. Guggenheim Museum Archives, New York.

Page 85: Excerpt from June 17, 1967, letter to Jan van der Marck, Director of the Museum of Contemporary Art in Chicago, in "some other comments . . . more pages from a spleenish journal," p. 23.

Page 86: Excerpt dated February 14, 1989, from "some more information . . . (to Sabine)," in *Neue Anwendungen fluoreszierendem Lichts mit Diagrammen, Zeichnungen und Drucken von Dan Flavin/ new uses for fluorescent light with diagram, drawings and prints from Dan Flavin* (Exh. cat., Baden-Baden: Staatliche Kunsthalle, 1989), p. 45.

Page 87: Excerpt dated February 18, 1989, in ibid., p. 46.

Page 88: "some remarks . . . excerpts from a spleenish journal," p. 27.

Biography
Kara Vander Weg

Dan Flavin was born in April 1933 in Jamaica, Queens, New York. From an early age, he expressed an interest in art, and particularly drawing, a medium the artist would use throughout his career. Flavin's artistic instruction was primarily self-imposed and informal with his first art lesson delivered by a family friend. After graduating in 1952 from Cathedral College of the Immaculate Conception in Douglaston, New York, he served in Korea from 1954–55 as a U.S. Air Weather Service Observer. Upon his return to New York, he studied art history at the New School for Social Research and Columbia University and completed four sessions at the Hans Hofmann School of Fine Arts. He briefly held positions in New York at the Museum of Modern Art, the American Museum of Natural History, and with the Guggenheim, where he was employed as a clerk during the construction of the museum's new building. The first public exhibition of Flavin's art occurred in 1957 at a group show held at the U.S. Air Force station in Roslyn, New York. He received broader exposure in a 1961 solo exhibition of his assemblages and watercolors—approaches that preceded his use of light—at the Judson Gallery, New York.

1961 marked the beginning of Flavin's use of electric light and the creation of his first "icon," which would occupy the artist for the next three years. In 1963, he began to work solely with commercially produced fluorescent bulbs with the completion of *the diagonal of personal ecstasy (the diagonal of May 25, 1963)*. Over the next decade his work took a variety of forms, including "corner pieces" (plate 2), "barriers" (plates 3 and 4), and "corridors" (plates 5 and 6). Many of the artist's pieces were dedicated to specific individuals or groups, several of whom inspired entire series (plates 8 and 9). One of the best known and most extensive of these begun in 1964 was dedicated to Russian Constructivist artist Vladimir Tatlin.

Flavin's work has been shown in numerous national and international venues and was part of the most important early exhibitions of Minimal art, including *Primary Structures* at the Jewish Museum, New York, 1966; and *Minimal Art*, at the Gemeentemuseum, The Hague, 1968; as well as the *Sixth Guggenheim International*, 1971. Significant among the many exhibitions dedicated solely to Flavin are *Alternating Pink and Gold* at Chicago's Museum of Contemporary Art, 1967; his 1969 exhibition organized by the National Gallery of Canada, Ottawa; concurrent 1973 exhibitions of his works on paper and fluorescent sculptures at The Saint Louis Art Museum, Missouri; a 1989 exhibition at the Staatliche Kunsthalle, Baden-Baden; an exhibition of new works in 1993 at the Städtische Galerie im Städel, Frankfurt; and shows at the Guggenheim Museum SoHo and Dia Center for the Arts, New York, during 1995–96.

In 1983, Flavin began renovating a former firehouse and church in Bridgehampton, New York, to permanently house several of his pieces. The building was renamed the Dan Flavin Institute and is maintained by Dia. Flavin's installation for the 1992 reopening of the Solomon R. Guggenheim Museum, New York, was an expansion upon the 1971 work he created for the same venue. One of his final site-specific sculptures, dated 1996, permanently illuminates two stairwells of Dia's main West Twenty-Second Street building in New York. During this same year, Flavin's work with blue and green fluorescents was permanently installed at the Hamburger Bahnhof, part of the Neue Nationalgalerie, Staatliche Museen zu Berlin.

Before his death in November 1996, the artist executed designs for an installation of colored light in Chiesa Rossa, Milan, a project that was realized in 1997. Flavin's largest fluorescent installation, consisting of four colors illuminating six buildings of the Chinati Foundation in Marfa, Texas, was initially conceived in 1981, and completion of the project is expected by the fall of 2000.

Selected Bibliography
Kara Vander Weg

Writings and statements by the artist

Statement in "The Artists Say," *Art Voices* (New York) 4, no. 3 (summer 1965), p. 72.

"'. . . in daylight or cool white.' an autobiographical sketch." *Artforum* (Los Angeles) 4, no. 4 (December 1965), pp. 21–24.

"Flavin Speech." *Blockprint* (Providence, R.I.) 15, no. 18 (March 21, 1966). Unpaginated.

"some remarks . . . excerpts from a spleenish journal." *Artforum* (Los Angeles) 4, no. 4 (December 1966), pp. 27–29.

"some other comments . . . more pages from a spleenish journal." *Artforum* (New York) 6, no. 4 (December 1967), pp. 20–25.

" . . . on an American Artist's Education . . . " *Artforum* (New York) 6, no. 7 (March 1968), pp. 28–32.

"several more remarks . . . " *Studio International* (London) 177, no. 910 (April 1969), pp. 173–5.

Flavin, Dan and Brydon E. Smith. "fluorescent light, etc. from Dan Flavin: a supplement." *Artscanada* (Toronto) 26, no. 5 (October 1969), pp. 14–19.

"some more information . . . (to Sabine)." *Neue Anwendungen fluoreszierenden Lichts mit Diagrammen, Zeichnungen und Drucken von Dan Flavin/new uses for fluorescent light with diagrams, drawings and prints from Dan Flavin*. Exh. cat., Staatliche Kunsthalle, Baden-Baden, 1989, pp. 45–46 (English); pp. 47–49 (German).

Books and exhibition catalogues

Dan Flavin: Pink and Gold. Exh. cat., Museum of Contemporary Art, Chicago, 1967. Statements by Roland Barthes, Dan Flavin, and Donald Judd; compiled by Dan Graham.

Dan Flavin: fluorescent light etc. Exh. cat., National Gallery of Canada for the Queen's Printer, Ottawa, 1969. Essays by Mel Bochner, Dan Flavin, Donald Judd, and Brydon E. Smith. In English and French.

drawings and diagrams 1963–1972 from Dan Flavin. Exh. cat., The Saint Louis Art Museum, Mo., 1973. Essay by Emily S. Rauh; statements by the artist.

corners, barriers and corridors in fluorescent light from Dan Flavin. Exh. cat., The Saint Louis Art Museum, Mo., 1973. Essay by Emily S. Rauh.

Dan Flavin: three installations in fluorescent light/Drei Installationen in fluoreszierendem Licht. Exh. cat., Wallraf-Richartz-Museums and Kunsthalle Köln, Cologne, 1973. Essay by Manfred Schneckenburger (in German); statements by the artist (in English).

Fünf Installationen in fluoreszierendem Licht von Dan Flavin and *Zeichnungen, Diagramme, Druckgraphik 1972 bis 1975 und zwei Installationen in fluoreszierendem Licht von Dan Flavin*. Exh. cats., Kunsthalle Basel and Kunstmuseum Basel, 1975. Introduction by Carlo Huber; essays by Dan Flavin, Donald Judd, and Franz Meyer; statements by the artist. In German; object descriptions in English and German.

Dan Flavin: drawings, diagrams and prints 1972–1975 and *Dan Flavin: installations in fluorescent light 1972–1975*. Exh. cat., Fort Worth Art Museum, Tex., 1977. Essays by Jay Belloli and Emily S. Rauh; statements by the artist.

Neue Anwendungen fluoreszierenden Lichts mit Diagrammen, Zeichnungen und Drucken von Dan Flavin/new uses for fluorescent light with diagrams, drawings and prints from Dan Flavin. Exh. cat., Staatliche Kunsthalle, Baden-Baden, 1989. Essays by Madeleine Deschamps and Jochen Poetter; essay and statements by the artist. In English and German.

Dan Flavin: installationen in Fluoreszierendem Licht, 1989–1993. Exh. cat., Städtische Galerie im Städel, Frankfurt am Main. Stuttgart: Edition Cantz, 1993. Essays by Beatrice von Bismarck and Klaus Gallwitz; statements by the artist. In English and German.

Dan Flavin: European Couples, and Others. Exh. pamphlet, Dia Center for the Arts, New York, 1995. Essay by Michael Govan.

Dan Flavin: (1962/63, 1970, 1996). Exh. pamphlet, Dia Center for the Arts, New York, 1997. Essay by Michael Govan.

Cattedrali d'Arte: Dan Flavin per Santa Maria in Chiesa Rossa. Exh. cat., Fondazione Prada, Milan, 1997. Essays by Carlo Bertelli, Christine Buci-Glucksmann, Germano Celant, Hubert Damish, Renato Diez, Michael Govan, Vittorio Gregotti, Fulvio Irace, Pierluigi Lia, Mario Perniola, and Gianni Vattimo.

Dan Flavin. Exh. cat., Centro Cultural Light, Rio de Janeiro, 1998. Essays by Chrissie Iles and Marc Pottier. In English and Portuguese.

Govan, Michael, ed. *Dan Flavin.* Dia Center for the Arts, New York, and Fundación Proa, Buenos Aires, 1998.

Articles and reviews

Baker, Kenneth. "A Note on Dan Flavin." *Artforum* (New York) 10, no. 5 (January 1972), pp. 38–40.

Burnham, Jack. "A Dan Flavin Retrospective in Ottawa." *Artforum* (New York) 8, no. 4 (December 1969), pp. 48–55.

Deschamps, Madeleine. "Dan Flavin Situations." *Art Press* (Paris), no. 121 (January 1988), pp. 32–35. In French.

Gibson, Michael. "The Strange Case of the Fluorescent Tube." *Art International* (Paris), no. 1 (autumn 1987), pp. 105–10.

Kalina, Richard. "In Another Light." *Art in America* (New York) 84, no. 6 (June 1996), pp. 68–73.

Leen, Frederik. " . . . notes for an electric light art (Dan Flavin)/ . . . notities voor een elektrisch-licht-kunst (Dan Flavin)." *Forum International* (Antwerp) 3, no. 15 (November–December 1992) pp. 71–82. In English and Dutch.

Plagens, Peter. "Rays of hope, particles of doubt." *Artforum* (New York) 11, no. 10 (June 1973), pp. 32–35.

Puvogel, Renate. "Über Dan Flavin: Bild-Objekte oder Licht-Körper." *Künstler: Kritisches Lexikon der Gegenwartskunst* (Munich) 13, (1991), pp. 3–11.

Skoggard, Ross. "Flavin 'According to his Lights.'" *Artforum* (New York) 15, no. 8 (April 1977), pp. 52–54.

Stockebrand, Marianne. "Pink, Yellow, Blue, Green and Other Colors in the Work of Dan Flavin." *Chinati Foundation News* (Marfa, Tex.) 2 (November 1996), pp. 2–11. In English and Spanish.

Wilson, William S. "Dan Flavin: Fiat Lux." *Art News* (New York) 68, no. 9 (January 1970), pp. 48–51.

———. "Dan Flavin: Specifying Light/Dan Flavin: Tornando Específica a la Luz." *TRANS>arts.cultures.media* (New York) 1, no. 2 (1996), pp. 111–15. In English and Spanish.

General books and catalogues
Batchelor, David. *Minimalism.* London: Tate Gallery, 1997.

Battcock, Gregory, ed. *Minimal Art: A Critical Anthology.* Revised edition, with introduction by Anne M. Wagner. Berkeley and Los Angeles: University of California Press, 1995.

Un Choix d'Art Minimal dans la Collection Panza: Carl Andre, Dan Flavin, Sol LeWitt, Robert Morris, Bruce Nauman, Richard Nonas, James Turrell, Lawrence Weiner. Exh. cat., Musée d'Art Moderne de la Ville de Paris, 1990. Essay by Phyllis Tuchman and interview with Count Giuseppe Panza di Biumo by Juliette Laffon and Suzanne Pagé. In English and French.

Colpitt, Frances. *Minimal Art: The Critical Perspective*. Seattle: University of Washington Press, 1993.

Krauss, Rosalind E. *Passages in Modern Sculpture*. New York: Viking, 1977.

Morris, Robert. *Continuous Project Altered Daily: The Writings of Robert Morris*. Cambridge, Mass.: The MIT Press, 1994.

Stemmrich, Gregor, ed. *Minimal Art: Eine Kritische Retrospektive*. Dresden: Verlag der Kunst, 1995.

General articles and reviews

Auping, Michael. "Beyond the Sublime." *Abstract Expressionism: The Critical Developments*. Exh. cat., Albright Knox Art Gallery, Buffalo, 1987.

Baker, Elizabeth C. "The Light Brigade." *Art News* (New York) 66, no. 1 (March 1967), pp. 52–54, 63–66.

Berger, Maurice. "Conceptualiser le minimalisme." *Art Press* (Paris) no. 139 (September 1989), pp. 31–35.

Bochner, Mel. "Primary Structures." *Arts Magazine* (New York) 40, no. 8 (June 1966), pp. 32–35.

———. "Serial Art Systems: Solipsism." *Arts Magazine* (New York) 41, no. 8 (summer 1967), pp. 39–43.

———. "The Serial Attitude." *Artforum* (New York) 6, no. 4 (December. 1967), pp. 28–33.

Burnham, Jack. "Systems Esthetics." *Artforum* (New York) 7, no. 1 (September 1968), pp. 30–35.

Celant, Germano. "La scultura un'architettura non abitabile." *Rassegna* (Bologna) 10, no. 36 (December 1988), pp. 16–28. Guest edited by Annalisa Avon and Germano Celant. In English: "Sculpture, an Inhabitable Architecture," translated by Sharon Krengel as supplement for editions distributed abroad [unpaginated].

Chandler, John and Lucy R. Lippard. "The Dematerialization of Art." *Art International* (Zurich) 12, no. 2 (February 1968), pp. 31–36.

Chave, Anna C. "Minimalism and the Rhetoric of Power." *Arts Magazine* (New York) 64, no. 5 (January 1990), pp. 44–63.

De Duve, Thierry. "Ex situ." *Cahiers du Musée National d'Art Moderne* (Paris), no. 27 (spring 1989), pp. 39–55. In French. Reprinted in *Art and Design Profile*, no. 30: *Installation Art*. Guest edited by Andrew Benjamin. Part of *Art and Design* (London) 8, no. 5/6 (1993), pp. 24–30. In English.

Foster, Hal. "The Crux of Minimalism." In Howard Singerman, ed. *Individuals: A Selected History of Contemporary Art, 1945–1986*. New York: Abbeville Press, 1986. Reprinted in Hal Foster, *The Return of the Real: The Avant-Garde at the End of the Century* (Cambridge, Mass: The MIT Press, 1986).

Fried, Michael. "Art and Objecthood." *Artforum* (New York) 5, no. 10 (summer 1967), pp. 12–23.

Gibson, Eric. "Was Minimalist Art a Political Movement?" *New Criterion* (New York) 5, no. 9 (May 1987), pp. 59–64.

Graham, Dan. "Art in Relation to Architecture/Architecture in Relation to Art." *Artforum* (New York) 17, no. 6 (February 1979), pp. 22–29.

————. "Kunst als Design/Design als Kunst." *Museumjournaal* (Amsterdam), no. 3–4 (1986), pp. 183–95. In Dutch. Republished as "Art as Design/Design as Art." *Parachute* (Montreal), no. 61 (January–March 1991), pp. 14–19. In English with summary in French.

Greenberg, Clement. "Recentness of Sculpture." *Art International* (Lugano) 11, no. 4 (April 1967), pp. 19–21.

Judd, Donald. "Specific Objects." *Arts Yearbook* (New York) 8, (1965), pp. 74–82. Reprinted in Donald Judd, *Complete Writings: 1959–1975* (Halifax: Nova Scotia College of Art and Design, 1975).

Kozloff, Max. "The Further Adventures of American Sculpture." *Arts Magazine* (New York) 39, no. 5 (February 1965), pp. 24–31.

Krauss, Rosalind E. "Sculpture in the Expanded Field." *October* (Cambridge, Mass.), no. 8 (spring 1979), pp. 30–44. Reprinted in Rosalind E. Krauss, *The Originality of the Avant-Garde and Other Modernist Myths* (Cambridge, Mass: The MIT Press, 1985).

————. "Overcoming the Limits of Matter: On Revising Minimalism." In James Leggio and Susan Weiley, eds., *Studies in Modern Art, 1* (New York: The Museum of Modern Art, 1991).

————. "The Reception of the Sixties." *October* (Cambridge, Mass.), no. 69 (summer 1994), pp. 3–21.

Kuspit, Donald A. "La Versione Minimalista dell'Arte Non-Oggettiva." *Rassegna* (Bologna) 10, no. 36 (December 1988), pp. 38–49. Guest edited by Annalisa Avon and Germano Celant. In English: "The Minimalist Version of Nonobjective Art," translated by Sharon Krengel as supplement for editions distributed abroad [unpaginated].

Kwon, Miwon. "One Place After Another: Notes on Site-Specificity." *October* (Cambridge, Mass.), no. 80 (spring 1997), pp. 85–110.

LeWitt, Sol. "Paragraphs on Conceptual Art." *Artforum* (New York) 5, no. 10 (summer 1967), pp. 79–83.

Onorato, Ronald J. "Being There: Context, Perception, and Art in the Conditional Tense." In Howard Singerman, ed., *Individuals: A Selected History of Contemporary Art, 1945–1986* (New York: Abbeville Press, 1986).

Reise, Barbara. "*Untitled 1969*: a footnote on art and minimal-stylehood." *Studio International* (London) 177, no. 910 (April 1969), pp. 166–172.

Robins, Corinne. "Object, Structure or Sculpture: Where Are We?" *Arts Magazine* (New York) 40, no. 9 (September–October 1966), pp. 33–37.

Rose, Barbara. "A B C Art." *Art in America* (New York) 53, no. 5 (October–November 1965), pp. 57–69.

————. "Sensibility of the Sixties." *Art in America* (New York) 55, no. 1 (January–February 1967), pp. 44–57.

Smithson, Robert. "Entropy and the New Monuments." *Artforum* (Los Angeles) 4, no. 10 (June 1966), pp. 26–31. Reprinted in Jack Flam, ed., *Robert Smithson: The Collected Writings* (Berkeley: University of California Press, 1996).

Soutif, Daniel. "Retour aux Sources." *L'Architecture d'Aujourd'hui* (Boulogne), no. 284 (December 1992), pp. 107–12.

Tuchman, Phyllis. "Minimalism and Critical Response." *Artforum* (New York) 15, no. 9 (May 1977), pp. 26–31.